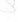

Painting from
PHOTOGRAPHS

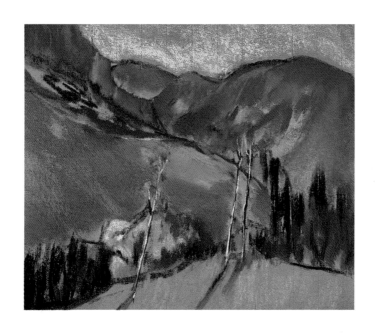

Previous page:
DIANA CONSTANCE
*Late Afternoon near
Florac*
pastel
420 x 495 mm
(16½ x 19½ in)

This page:
DIANA CONSTANCE
Detail of *Ferry to
Paros*
gouache
305 x 280 mm
(12 x 11 in)

COLLINS

Painting from PHOTOGRAPHS

DIANA CONSTANCE

HarperCollins*Publishers*

AUTHOR'S ACKNOWLEDGEMENTS

This book has drawn on the skills, artistry and honesty of many people. I am deeply grateful for the integrity of the professional artists represented here in sharing their work and techniques with us. I would also like to thank my students at The Hampstead School of Art in London for their enthusiasm and the fine work they have contributed to this book.
In addition, I would like to thank Cathy Gosling, Caroline Churton and Caroline Hill at HarperCollins.

PUBLISHERS' ACKNOWLEDGEMENTS

The publishers would like to thank John Gilboy at Daler-Rowney for his support and encouragement in connection with this book.

First published in 1995 by
HarperCollins Publishers, London

© Diana Constance, 1995

Diana Constance asserts the moral right to be identified as the author of this work.

A catalogue record for this book is available from the British Library

Design Manager: Caroline Hill
Designers: Peter Laws and Amzie Viladot

ISBN 0 00 412712 9

Set in Gill Sans and Copperplate
Produced by HarperCollins Hong Kong

CONTENTS

INTRODUCTION

I am indebted to my students for this book. Frequently after a class they have shown me work done at home, accompanied by profuse apologies for 'cheating' – because the painting was done from photographs.

I see no reason why students should not enjoy the same benefits that many professional artists have experienced since 1839, when photography was invented. Painting from photographs opens the door of the studio – thousands of images from all over the world become available subjects. You can paint things you have never seen, or explore the familiar in new and exciting ways. Personalized images such as your family photographs can be given deeper expression.

There are many ways of painting from photographs, from the extremes of sharp-focus photo-realism to highly imaginative explorations which use the photographic image only as a starting point. It enables you to experiment with composition – working from a two-dimensional image means that a subject you might have found too difficult to draw freehand can be traced and transferred several times. You can develop a series of paintings from a single photograph, or combine different images in one painting. Using photographs as reference opens up new approaches to technique and interpretation.

However you choose to use your material, I believe your painting experience will be enriched by the opportunities of painting from photographs. Remember, no apologies are required – welcome to the club!

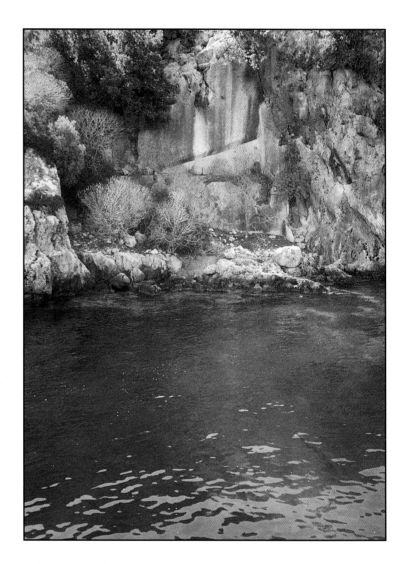

▲ Source photograph for *The Sunken City of Kekova, Turkey* by Diana Constance.

▶ **DIANA CONSTANCE**
The Sunken City of Kekova, Turkey
pastel on grey paper
735 x 560 mm
(29 x 22 in)



A NEW PAINTING TRADITION

The search for an objective and accurate instrument for observing nature began in the 11th century, with the discoveries of Alhazen, an Arab scientist. He was the first to understand the principles of optics which form the basic theory of vision and photography. Four hundred years later, Leonardo da Vinci's anatomical studies of the workings of the human eye gave artists the first inkling of what such a device might look like, and provided a word for it – camera.

In the 17th and 18th centuries, artists as diverse as the Dutch painter Vermeer, the Italians Canaletto, Tiepolo and Guardi, and English watercolourists John Crome and Thomas Girtin all used the device known as the *camera obscura* (dark chamber) to provide images of reality that could be used as a guide to painting. The *camera obscura* was merely a black box with a pinhole at the front and a ground glass screen at the back; light entering through the pinhole cast an image on to the screen, which could be copied or traced from the outside.

FIXING THE IMAGE
The breakthrough to modern photography came early in the 19th century. Joseph Nicephore Niepce and Louis-Jacques Daguerre, both working in France, developed effective methods of recording images formed by light. But the talented English 'amateur' inventor and artist William Fox Talbot became the accepted father of photography, because he developed a method of reproducing a positive image from a negative. He published details of his invention, the Calotype, in 1839, shortly before Daguerre announced his method of making positive photographic prints on metal, known as Daguerrotypes.

The French Romantic painter Eugène Delacroix (1798-1863), a noted orientalist,

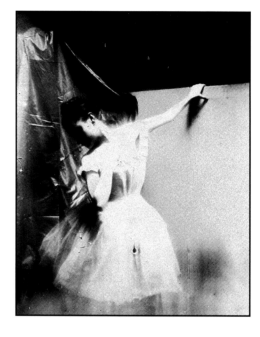

◀ Photograph of a dancer taken by Degas in his studio.
REPRODUCED COURTESY OF WEIDENFELD & NICHOLSON LTD

was the first master-painter to work directly from photographs. His own album of photographic studies was freely used to provide figure reference for his harem pictures. The Realist painter Gustave Courbet (1819-77) was advised by his patron, Alfred Bruyas, to experiment with the new technique. In his huge canvas, *The Artist's Studio* (c.1855), the model who is a centrepiece of the composition was probably painted from a photograph; there is documentation that Courbet requested return of such a picture from Bruyas when he began work on the painting.

IMPRESSIONISM AND PHOTOGRAPHY
Although part of the Impressionist ethic was that painting from life was of paramount importance, two artists closely associated with Impressionism, Edouard Manet (1832-83) and Edgar Degas (1834-1917), both made good use of photography. Manet's interest in news events on occasion

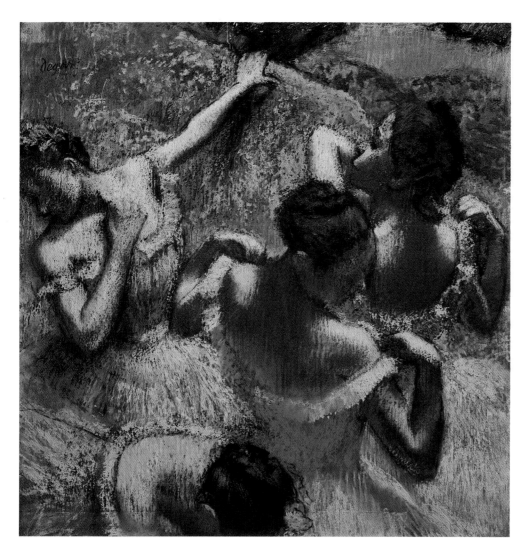

◀ **EDGAR DEGAS**
Blue Dancers (c. 1899)
pastel
650 x 650 mm
(25½ x 25½ in)
REPRODUCED COURTESY OF
PUSHKIN MUSEUM, MOSCOW/THE
BRIDGEMAN ART LIBRARY

prompted him to select his subjects from the day's headlines. He used engravings taken from photographs to construct his *Execution of Maximilian*, a large painting that went through several variations as changing reports of Emperor Maximilian's death in front of a Mexican firing squad were published in the French newspapers of 1867.

Degas was the true 'camera buff' of the Impressionists. He bought one of the first Kodak cameras (which came on the market in 1888), and photographic sources are obvious in many of the unconventional figure poses in his paintings. Where the camera really came into its own for Degas was in capturing the elusive movements of his favourite subjects – dancers and racehorses. It is no coincidence that the dramatic and beautiful paintings of these subjects date from the arrival in Paris of

Eadweard Muybridge's sequential photographs of human and animal locomotion, first published in the United States in the late 1870s.

Degas's original inspiration for his dancers possibly went back to the 1860s, when Disderi had brought out a popular series of photographic studies showing the sequential movements of ballet dancers. In 1883 Degas, with the fresh inspiration of Muybridge before him, painted *Dancers Tying their Slippers*, in fact a single dancer shown in the same pose from different angles. One photograph, which Degas took himself, probably in 1897 or 1898 (see opposite), provided the model for the left-hand ballerina in his ravishing pastel painting *Blue Dancers*.

Degas 'was one of the first to study the true appearance of the noble animal by

means of Major Muybridge's instantaneous photographs', according to his friend Paul Valery. Degas's earlier sketches and paintings of horses used relatively static poses, or their movement was described in the stylized ways popularized by British sporting prints – for example, showing the animal galloping with all four legs flung outwards. From the time he was able to study the Muybridge photographs that captured the much more complex articulation of a running horse, we see Degas's beautiful creatures caught in realistic motion, their glistening coats and the jockey's colourful silks adding to the liveliness of the pictures.

After Degas's death, photographs of landscapes and washerwomen were also found in his studio. The latter, of course, had been the inspiration for many of his later pastel paintings. Degas used the then standard photographer's equipment of a tripod and glass plates, photographing at night just by lamplight or moonlight. His models would have to hold very long poses in the weak light for these strange, ghost-like images.

PHOTOGRAPHY IN MODERN ART

Edvard Munch (1863-1944), the Norwegian painter whose work marked the beginnings of 20th-century expressionism, recognized the advantages that image-synthesis via photography could give to his work. He experimented in his own darkroom, using double exposures and other special techniques to combine and alter the images. Some of his surviving photographs even bear his thumbprints. However, he also used photography as a more direct form of reference, as with the photograph of a studio model translated into the painting *Naked Woman*.

During the 1920s and 1930s, photography became increasingly important to artists, both as reference material and as an art form in its own right. The American photographer Man Ray, working with the French Surrealist artists in Paris during those decades, measurably blurred the line between photography and painting with his sensuous experimental images.

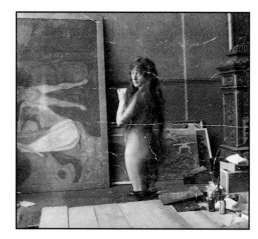

◀ Photograph of the artist's model posed in Munch's studio, Berlin (1902).
REPRODUCED COURTESY OF THE MUNCH MUSEUM, OSLO

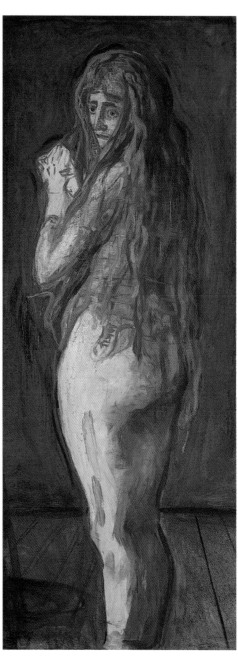

◀ **EDVARD MUNCH**
Naked Woman (1902)
oil on canvas
1020 x 495 mm
(40 x 19 ½ in)
REPRODUCED COURTESY OF THE MUNCH MUSEUM, OSLO

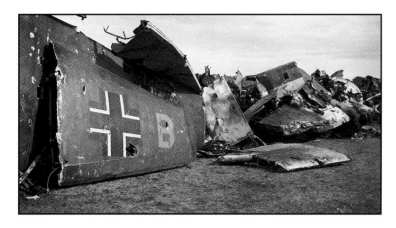

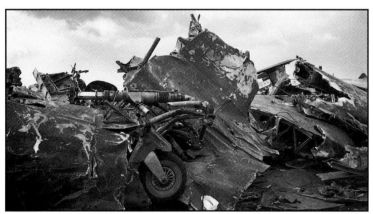

These were among the influences called upon by the British painter Paul Nash (1889-1946), who produced a number of strange paintings full of impact while working as an official war artist in Britain during the Second World War. For what has been judged his finest work, *Totes Meer* (Dead Sea), Nash photographed a huge aircraft dump at Cowley, near Oxford, of German planes shot down during the Battle of Britain; 74 exposures were taken on site. He wanted to exhibit both the photographs and the preparatory watercolours he had made for the canvas, but his request to include the photographs was flatly refused. Nash commented, 'no one understands how photography can be used for art except as a method of cheating.'

◄ Source photographs for *Totes Meer* by Paul Nash.
REPRODUCED COURTESY OF THE TATE GALLERY, LONDON

▼ **PAUL NASH**
Totes Meer (1940-41)
oil
524 x 1016 mm (20¾ x 40 in)
REPRODUCED COURTESY OF THE TATE GALLERY, LONDON

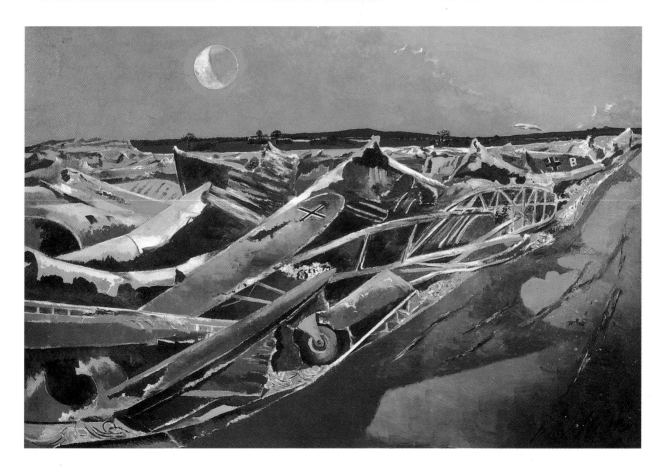

▲ Close-up portrait of Ossie Clark.

By the 1960s, the role of photography in art was consistently under discussion. American and British 'Pop' artists, focusing on the ubiquity of photographic images in television, advertising and all forms of publishing media, reflected the immediacy of this continual record of everyday life. Andy Warhol (1928-87), a former graphic artist, developed his technique of silkscreening photographic images directly on to paper or canvas. His work is well known for recording the icons of his time, such as movie stars and consumer products, in brilliant colours laid into the photographic frameworks.

Similarly, other artists used found photographs and modified them, by collage, printmaking and painting, to create artworks wholly distinctive of their period.

Among contemporary painters, David Hockney (b. 1937) has been one of the most unapologetic users of photographs, as reference for portraits, figure and landscape compositions, and also in their own right (as montaged photographic images). An example of the former method is the basic composition of his painting *Mr and Mrs Clark and Percy*, which directly relates to a single reference photograph taken for the work.

The poses of the figures (and the cat) appear almost exact, although a number of surrounding details have been altered. An important element was the expression of the woman in the portrait, fashion designer Celia Birtwell; in the main photograph she appears uninterested and bored. Hockney took a series of pictures of her on a separate occasion (see opposite), in the same position and light as the original double portrait, and used these as additional reference for the painted version.

▶ Contact sheet of
close-up photographs of
Celia Birtwell.

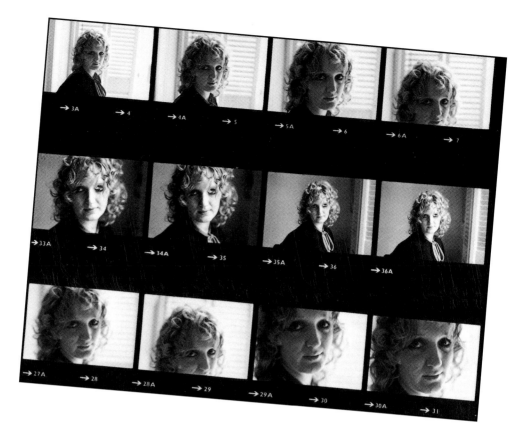

▼ DAVID
HOCKNEY

*Mr and Mrs Clark and
Percy* (1970-71)
acrylic on canvas
2135 x 3050 mm
(84 x 120 in)

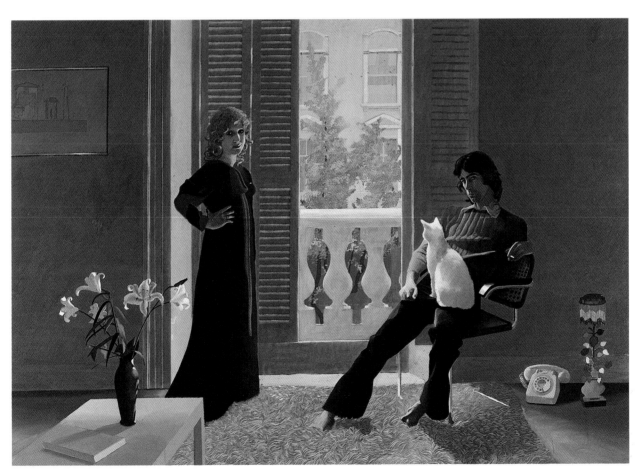

USING FOUND PHOTOGRAPHS

Many contemporary artists are skilled photographers, but many also work from 'found' pictures that simply catch the imagination or inspire painterly investigation. British artist Tom Phillips (b. 1937) has used 'found objects' for a great deal of his work. He does not paint directly from the photographs or postcards: 'There is too much already there.' Instead he 'degrades' the images in a photocopier or laser printer, so that at times only traces of the originals remain.

These imperfect images lend themselves more readily to imaginative interpretation and exploration. The found picture becomes almost a relic, as the humble original is transformed into an archetype, a manufactured memory vaguely familiar to us all.

In his *Quest for Irma* series, Phillips has simulated colour reproduction by building the form with hundreds of coloured dots. (Photographs in books and magazines are reproduced using dot-pattern screens that separate all colours into four 'process' colours; the colour variations are reconstituted by the dot patterns mixing in different proportions.) The use of the dot technique creates movement and slight colour vibration in the paintings. The degraded found image is transformed into a 'postcard' from the artist's imagination.

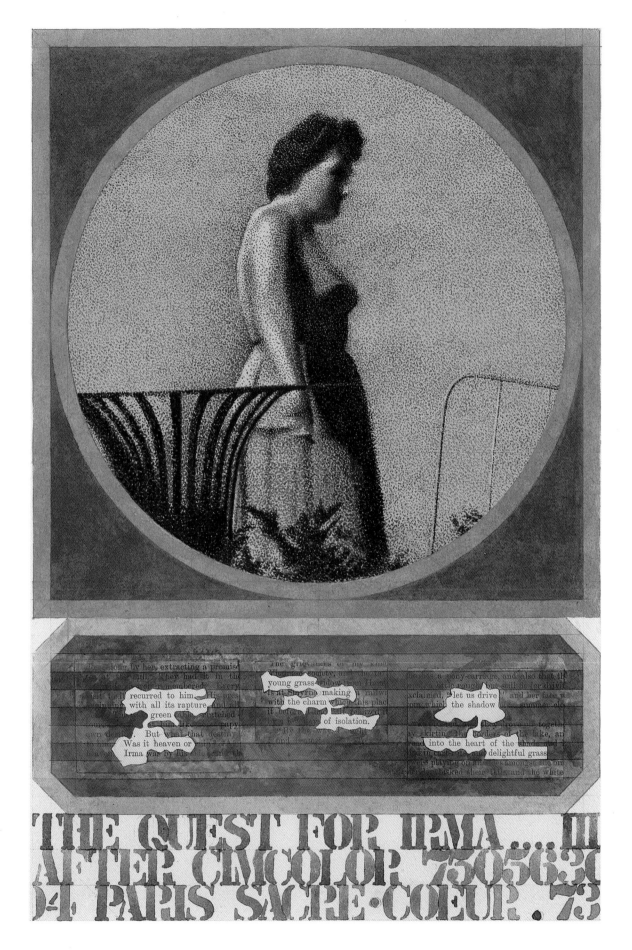

PHOTOGRAPHY FOR THE PAINTER

Selecting a photograph is a matter of individual choice. A fine photograph can be difficult to work from, since it is a complete statement which leaves little for the painter to do except copy. The successful source photograph is more likely to be the rather odd thing with an indefinable quality that you keep coming back to. The best painting extends, develops and completes the picture. There is, after all, no sense in just restating what has already been said – it is your own personal input that is essential.

The greatest value of using photography for painting comes from taking your own photographs. As well as being able to choose your viewpoint on the subject, you absorb direct experience of it into your memory, which later supplements and enriches what you can get from the photographic information when you start to paint. But you may also find that your inspiration comes from pictures in magazines or the daily newspaper, or from postcards.

PLANNING YOUR PHOTOGRAPH

Luck plays its part in photography, but it is better to rely on good planning and to learn to recognize the right opportunity. Whenever possible, plan your photography beforehand so that the time of day will be right for your subject. On many occasions I have waited patiently for the dawn's silvery light or the warm tones and long shadows of early evening to turn a landscape into a thing of magic. Patience is also important when you are photographing people. You must allow your subjects to relax and 'forget' about the camera, while you remain alert and ready to catch the perfect moment (see opposite).

▼ The importance of waiting for the right time of day to catch an interesting light on the subject is shown by this useful photograph. It has all the interesting colours and forms needed for a painting.

▲ The setting of this photograph is particularly attractive and would make an excellent subject for a painting.

► This photograph was taken late in the afternoon. I wanted a side light with a strong pattern of shadow to bring out the forms and textures of the ruins. The midday sun would have bleached out the colours and flattened the forms.

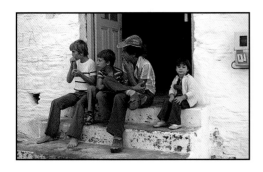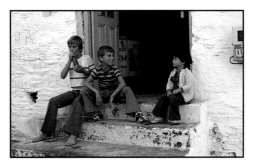

Patience is needed to photograph people successfully (left and below). Instead of trying to pose the children, I kept the camera focused and talked to them until the right moment came.

USING YOUR CAMERA

Keeping in mind the ambiguous nature of inspiration, there are certain techniques that will help you to take photographs useful for painting. The interests of good photography and painting overlap in great part, but they are not always the same – painting has its own special needs.

It is important to understand at the outset that light is drawing the image on to the film in your camera. The lens is not seeing solid objects, but the light reflected from them. The camera is designed to be able to admit exactly the amount of light needed for a particular image in the given lighting conditions. Modern cameras are versatile and there is usually more than one option in creating the exposure on film. The precise way you set the camera mechanisms can modify particular qualities of the image.

Most modern cameras are adjusted to the shot automatically by the camera's internal programming. If you have an older camera or a manual SLR, you may have to set the aperture and speed manually according to a light-meter reading; on automatics, you may also have a manual override facility which can be useful in unusual lighting conditions.

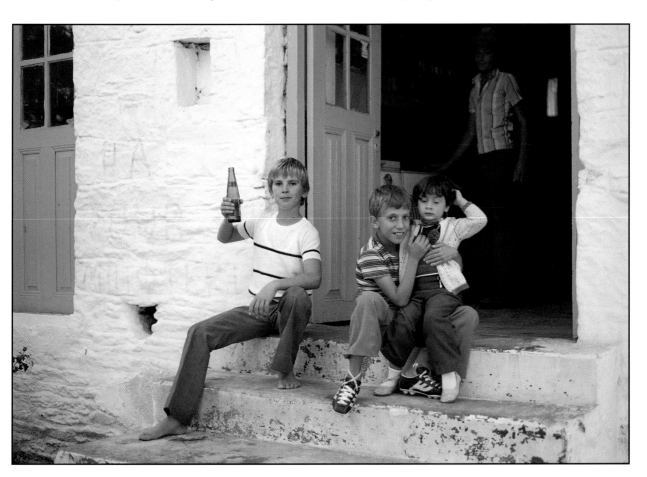

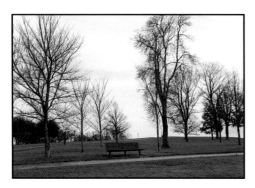

◀ The first photograph (top) was taken in poor light in early evening on a dull winter's day. The aperture was set at f1.8 but the camera was hand-held during the long 1-second exposure, resulting in a fuzzy image. For the second photograph (bottom) a tripod was used to hold the camera steady, so although the aperture setting and exposure time were the same, the resulting image is sharp.

The setting for the aperture is measured in f-stops. This is a specific form of numerical coding which applies to all types of lenses: for example, f1.4 is a large aperture; f64 the smallest. The aperture is set according to the readings of a light meter which is usually within the camera (separate light meters are generally used in professional photography).

The aperture setting affects the photographic element called 'depth of field'. Basically, this refers to the degree of focus within a certain range, or field, from the point you are focusing on.

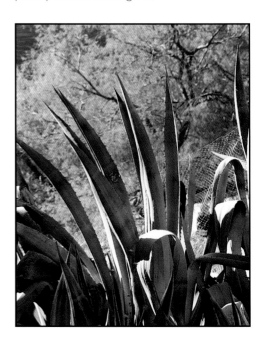

SHUTTER SPEED

The shutter can open and close in 1/1000th of a second on a bright sunny day, or stay open for more than a full second if the light is poor. On a bright day, there is typically enough light to record an image in 1/500th of a second; this will allow you to take a sharp picture of a boy running.

If you take a shot of the boy running in evening light, the camera's shutter must remain open longer to admit enough of the weak light to make an image. On longer exposures, the slightest movement records as a blurred image; actual detail of the subject is lost.

Another problem with long exposures is 'camera shake', which also blurs and distorts the image. However steady your hands, you will make some imperceptible movement while holding a camera for longer than 1/60 of a second, which will blur the image on film. For shooting in low light you get best results by using a tripod to keep the camera steady. You can also compensate by choosing a 'fast' film (see opposite).

APERTURE SETTINGS

The aperture is set by an arrangement of overlapping blades, forming a hexagonal opening that can be enlarged or contracted.

▶ To soften the background for a clearer composition a 135mm telephoto lens with a fast shutter speed of 1/500th of a second was used here, with the aperture set at f4. This combination eliminated any camera shake and produced a shallow depth of field with only the cactus in focus.

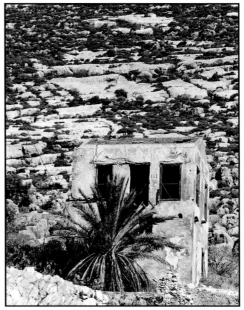

◀ A fine-grained 100 ASA film was used to photograph this ruined house, built into a steep hillside. It was a very bright day and a long depth of field was obtained by using a 50mm lens set at 1/125th of a second with an aperture setting of f22. Both the hillside and the foreground are in sharp focus.

Shallow depth of field is shown in the type of picture in which a foreground feature is focused and the background fades almost into a blur; this happens with larger apertures (lower f-numbers). A deeper range in the depth of field enables you to maintain greater detail through distance; for example, in an open landscape shot. For the greatest depth of field, use the smallest aperture (highest f-number) possible in given conditions.

TYPES OF FILMS

Most commonly used cameras take 35mm film. In this range, you have a choice of colour print film, colour transparencies, or black-and-white negative film. Colour print film will probably be most useful to you under most circumstances; you can have prints enlarged by a commercial processor, or have them copied at larger sizes on a colour laser copier.

Direct projection of colour transparencies (slides) on to your paper or canvas is an interesting way of constructing the composition for a painting, but to see the image clearly you have to work in low light, so slides are useful for drawing stages but perhaps not for immediate reference while painting. A copy bureau will also reproduce 35mm slides as colour laser copies; some accuracy is lost, but the copy is a useful larger-scale reference.

FAST FILMS FOR POOR LIGHT

Using flash is one way of compensating for poor light. However, the illumination of a flash is not far-reaching, and its harsh light makes rounded forms look rather flat – an effect which is a serious drawback for a painter. For our purposes, a fast film is a much better option than flash for coping with poor lighting conditions.

The ASA numbers on film packs denote the sensitivity of the film to light. ASA is an industry standard, and you need to know the practical effect of choosing different films. Films of 100 or 200 ASA are adequate for bright daylight. For poor daylight or evening light, you can go to 400 ASA, and for very murky conditions, to 1000 ASA.

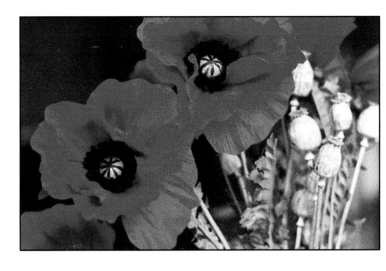

Automatic cameras read the ASA from the film cartridge when you load, and work out the relationship of shutter speed and aperture settings accordingly. However, with some cameras you have to change the ASA setting yourself – failure to do so will result in incorrect exposure.

▲ Poppies photographed indoors in natural light using 1000 ASA film. Although the grain is coarse, the photograph is quite acceptable as a reference source and of better quality than one taken with a flash.

▲ A flash was used, with 200 ASA film, to take this photograph (above). As a result, the form of the face has been flattened, making this a difficult photograph to paint from. The flash has also cast a distracting hard shadow. For the second photograph (right), 1000 ASA film was used, making a flash unnecessary. The resulting image is more defined.

Everything has its price, and some ultra-sensitive fast films have a coarse grain. This may knock out some detail, and the tonal balance of the image is usually flatter than with normal-speed films. Fortunately, however, new ultra-fast films with fine-grain qualities have recently been developed. The Kodak Ektar 1000 ASA film should transform the possibilities of photography in poor lighting conditions. For example, it should now be possible with this film to take a reasonable photograph inside a house, using the existing daylight from the windows.

SLOW FILMS FOR DETAIL AND TEXTURE

Films with the lowest ASA numbers (50-64) have extremely fine grain. They are ideal for capturing detail and texture, but need strong light or a long exposure with the camera held on a tripod.

Moving in close to the subject can be just as important to a painter as to a photographer. Details of flowers or landscape may be more interesting than the whole scene. In portraiture, a close-up can make a more intimate and telling picture than one taken from further away. You can achieve good results using a slow film in very strong light. One point to remember is that slow films give high contrast between lights and darks, due to the density of the grain.

BLACK-AND-WHITE FILM

Black-and-white film is no longer popular for everyday use, but it can still be obtained in most photographic shops, to which it can be returned for processing. Black-and-white prints provide some great advantages for the painter-photographer. A strongly defined tonal image can be inspirational as to the mood of the painting, and leaves you free to develop colour qualities imaginatively.

▼ This photograph was developed and printed by the author. Many artists prefer to print their own black-and-white photographs as this allows them the opportunity to compose the negative image and change the tonal balance to suit their needs. A strongly defined tonal image such as this provides an ideal subject for a painting.

It is possible to develop and print from the negatives yourself, provided you have a room with adequate ventilation that can be blacked out and used as a darkroom. Remember to take suitable care when handling all photographic chemicals. If you have the right equipment, home enlargements can be made from the negatives; being able to enlarge and crop your own images however you wish, to select part of the composition or to enlarge a detail, for example, can be extremely useful.

LENSES FOR SLR CAMERAS

Lenses have different focal lengths. Most cameras will come fitted with a lens that works adequately in a range of the most usual picture-taking situations. If you wish to have a greater number of options for close-up or distance work, you can choose to obtain extra lenses for your SLR camera.

The type of lens your camera has is indicated by a number on the rim of the lens. If your main interest is portraiture, select an 80mm lens, which approximates the natural vision of the human eye at a medium distance. For landscapes, a 35mm lens would be a better choice, or you may need a zoom or telephoto lens (see page 22) for detailed photographs of flowers and wildlife. This does not mean that different lenses are mutually exclusive. I enjoy using my 80mm lens for landscape as well as portraiture, accepting that the landscape shot taken with this lens will be a smaller 'slice' or angle of the view than a 35mm lens would give.

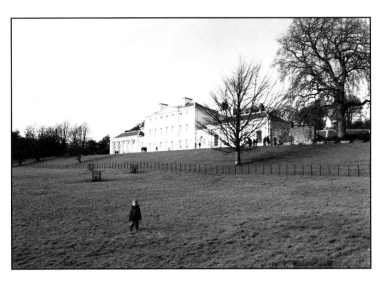

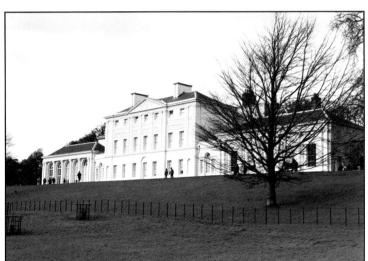

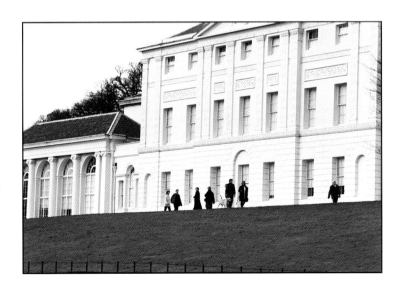

▶ The same subject, Kenwood House in London, photographed from exactly the same position but with lenses of differing focal lengths: 28mm lens (top); 50mm lens (centre); and 135mm lens (bottom). Similar results can be achieved with a single zoom lens.

ZOOM AND TELEPHOTO LENSES

The human eye changes focus automatically from reading words on a page to looking out of the window. Zoom lenses are an attempt to copy this versatility. Separate interchangeable lenses can cover the range of variations, but they are not as convenient as using a zoom.

Zoom and telephoto lenses move you in close, so that you can photograph a scene without disturbance or crop into details of a subject. Because these cameras focus on a short depth of field, accuracy of focusing is important. Camera shake can also be a problem on longer exposures.

The new, popular compact cameras now widely available combine convenience with a full range of zoom lenses that are an integral part of the camera. These cameras can be carried on your belt or in a bag, enabling you to take photographs whenever you wish to add to your useful collection of photographic sources for painting.

FILTERS

Some filters to adjust the quality or colour of the light entering the camera are not essential for the artist-photographer. As you have the option to make colour changes easily on the paper or canvas, it is not often worth your while to make complicated adjustments to the photograph.

There is, however, an important use of a blue filter for a painter. If you are photographing indoors in normal lamp light, a blue filter corrects the golden colour of the tungsten bulbs, enabling you to photograph without use of special tungsten-balanced film.

If you are photographing outdoors in mountainous or hazy conditions, an ultra-violet filter clears the atmosphere, giving a sharper shot. For black-and-white film, yellow, orange or red filters can be used to bring out cloud effects by darkening the tone of the sky. Light yellow gives a very subtle change, whereas dark red will turn the sky almost black.

A polarizing filter can be used to photograph subjects through glass – a window, for example – and it can be useful

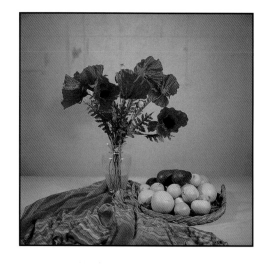

◄ The golden glow in this photograph is caused by the warm light of tungsten spotlights in the studio. This yellowing will occur whenever daylight film is used with indoor lighting.

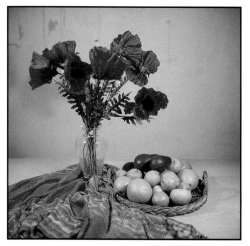

◄ The use of a blue filter counteracts the warm light of tungsten lights. Alternatively, a tungsten-sensitive film will produce the same effect.

for taking photographs of glazed work without having to remove paintings from their frames. It also eliminates most reflections from china or sculpture.

TRIPODS

A heavy tripod holds your camera completely still for very long exposures. This is essential if you are working in poor light, or want a long depth of field for landscape. By using a long exposure, the lens aperture can be closed down to f22 or even f64 on a fine camera, giving the greatest definition of detail. A tripod need not be very expensive, but choose a sturdy, fully adjustable model.

If you work out in the landscape, you may find a camera easel useful. This is a painter's easel that converts to take a camera-mounting platform. The main advantage on location is that you do not have to carry two pieces of equipment into the field.

WORKING FROM FOUND PHOTOGRAPHS

Photographs 'found' in newspapers and magazines, or material such as postcards and old photograph albums, can open up new and exciting ideas. They can be interpreted directly, or combined with a variety of other photographs or drawings.

A frequent advantage of this practice is that found photographs offer you valuable instruction on composition. Professional photographers have a marvellous eye for the potential in a subject that the average person would not glance at twice. To understand what makes a picture work, try turning it upside down and looking at the tonal structure – the balance of light and dark. Photographers generally get in closer to their subject than painters by cropping out all irrelevant material. Most of all, they value light as the key element of a composition, something studio-bound painters can forget.

You can keep a file of interesting found photographs and use them singly or in combination. With some older illustrations, you may realize that the colour balance is distorted. I find that inconsistencies of this kind can be a source of new ideas for exploration.

▲ Old photographs in family albums make marvellous painting subjects. The sepia tint can be retained or full colour can be introduced.

▲ The colour in this old postcard was laid over a black-and-white print, a process which gives a clear structure to the forms — ideal as a source for a painting.

◀ Postcard source for *Mykonos* by Julia Bastian.

◀ **JULIA BASTIAN**
Mykonos
pastel
240 x 355 mm
(9½ x 14 in)
By increasing the contrast of tones in the highlights the artist has given this pastel a life and light that the old postcard lacked.

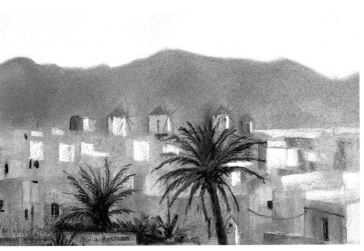

USING A CAMERA EASEL

John Crossland was drawn to this ruined French farmhouse for its slightly forlorn, enigmatic quality. The contrasting courses of grey-russet granite and pale blue window frames were also attractive visual qualities that suggested effective interpretation in paint. Rapid weather changes in the Cévennes region of France can cut short the painting time during a holiday, but John was lucky to get one last day of weak sunlight on which he could revisit the site.

Using the camera easel, he was able to take a few working photographs of the subject. The tripod facility enabled him to take sharp pictures over a greater depth of field than would have been possible with the camera hand held. He took several photographs of the farmhouse from different angles, including shots of an old vine growing around the side that formed good shape and detail against the rather austere façade of the building. The light changed continually as he worked.

Back in his studio, John decided to crop and rearrange the composition from the photographs, concentrating on the angle of the farmhouse wall and the blue window frames. The watercolour was composed using three pictures. The artist preferred the composition of the first photograph he had taken – unfortunately in poor light before the sun came fully out. The effect in the second photo, with a brief glow of sunlight, was more interesting, and the diagonal shadow gave a dramatic line to the composition. The rich chestnut foliage overhanging the house acted as a natural frame to the top and left side of the image. Bursts of vivid foliage from the vine in the third photograph provided strength and interest at the junction of the farmhouse walls and also helped to balance the composition overall.

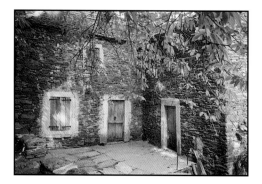

◀ The first photograph of the farmhouse. Although limited because the sky was overcast, the light was even, showing up the detail of the farmhouse.

◀ As the camera easel was positioned to adjust the composition, the sun came out more strongly, creating hard shadows.

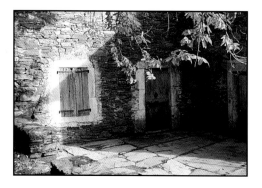

◀ The second shot has a more dramatic mood, but the lit areas are bleached out and the shadows too dark, making it difficult to define form and space.

▶ The vine on the side wall was photographed separately for detail reference.

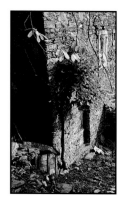

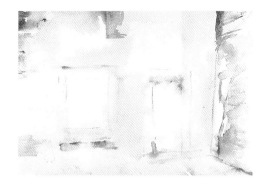

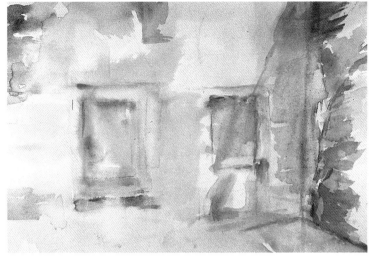

▲ STEP 1

Instead of using the variable greys of the façade, the artist decided to enhance the colour effects, creating a warm and cool balance. He laid in broad washes of alizarin crimson, which were offset by pale ultramarine for the windows and shadows and sap green for the vine.

▶ STEP 2

The second stage of the painting was gradually strengthening tones and colours with successive washes to develop the pattern of light and shade. An important feature was emphasizing the dappled effect of the shadows on the warm-toned wall of the farmhouse.

▼ JOHN CROSSLAND

Stone Farmhouse in the Cévennes
watercolour
305 x 420 mm
(12 x 16½ in)
In the finished painting, the feeling of warmth and freshness has been recaptured through distinct colour contrasts on the façade and the addition of harder-edged foliage detail framing the vertical planes.

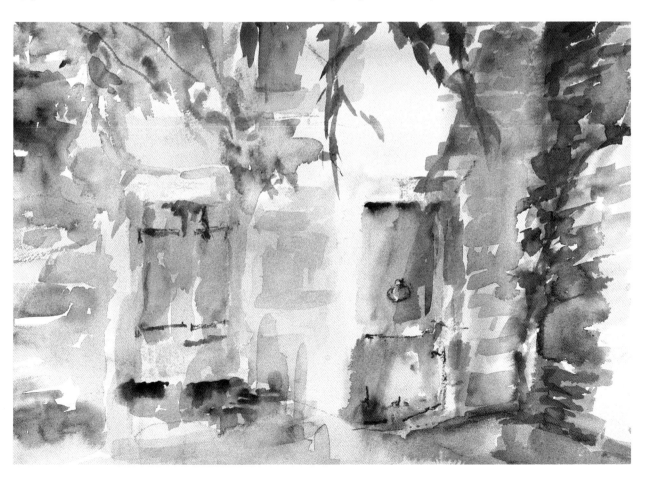

IMAGE-TRANSFER TECHNIQUES

Before we can begin to paint from photographs, the images have to be taken from the prints and transferred to the canvas or paper. The most obvious way is to draw whatever you have selected, but this is not as easy as it seems. The scale and complexity of a photograph makes it a difficult subject to enlarge by drawing freehand. Many artists use photocopiers or laser printers to increase the size of the print, making the image easier to see and draw.

SCALING UP

With any enlargement the first step is to make sure the proportion of the paper or canvas you intend to work on is the same as that of the source picture you are using. There is an easy way of doing this diagrammatically.

Place the photograph exactly at the corner of the paper. Join two opposite corners of the photo with a diagonal line and extend this line on to the paper (see artwork). The enlargement will be scaled up in correct proportion by placing its corner at any point along the diagonal line.

A traditional technique for enlarging the image itself is to use a grid of squares. You draw a suitably sized grid on the photograph you wish to enlarge (or on a tracing paper or acetate overlay if you do not want to mark the picture). Then you draw a larger grid in the same proportion on the paper or canvas, with the same number of squares. To enlarge the image overall, you copy the main outlines square by square.

This has the advantage of being more accurate than freehand drawing while being independent of any special photographic equipment. For centuries, it was the primary method of copying and enlarging drawings.

Acetate in pads or rolls is available from most art materials suppliers. Use a permanent-ink marker pen to avoid smudging. If the photograph is very dark, try scoring the acetate with a needle or knife blade, so you see a faint white-line grid.

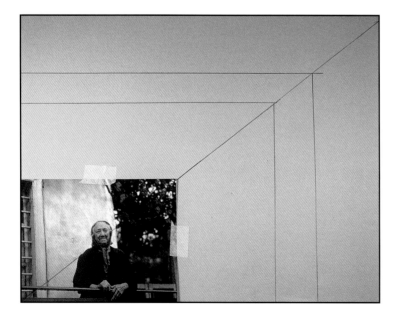

◀ Scaling an image in proportion using the diagonal. This example shows three different sizes of rectangle that could be used for the enlarged picture; all are in exact proportion to the original photograph.

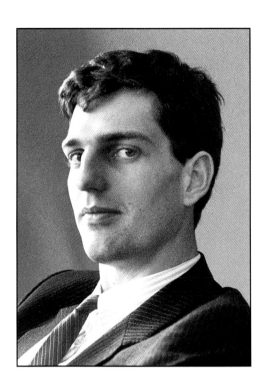

◀ Reference photograph for *Portrait of a Young Man* by Francis Martin.

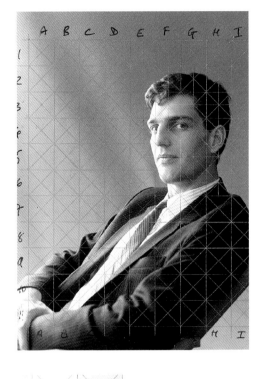

▶ The photograph overlaid with acetate ruled with a grid. The grid has been drawn by scoring the acetate, and shows up as white lines.

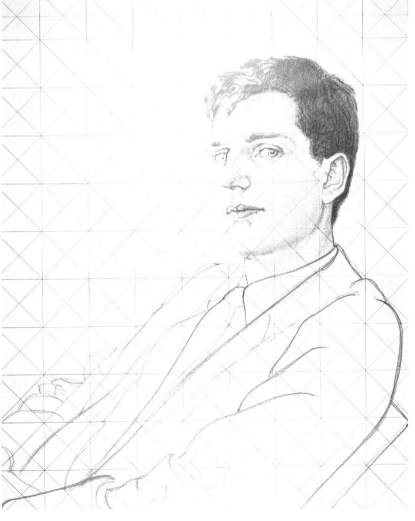

◀ Pencil drawing on a scaled-up grid; the diagonal lines through the grid help to increase the accuracy of the drawing. The image has been enlarged from 140 x 115 mm (5½ x 4½ in) to 560 x 455 mm (22 x 18 in), and rendered as a full tonal study which the artist will use as his guide in the composition of the portrait. The work can now be traced directly on to a canvas of the same size, or enlarged on to a bigger canvas by the same scaling-up method.

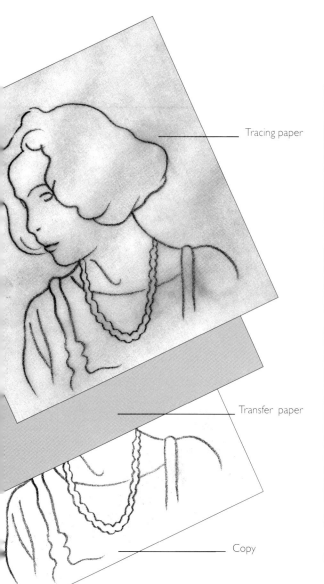

Tracing paper

Transfer paper

Copy

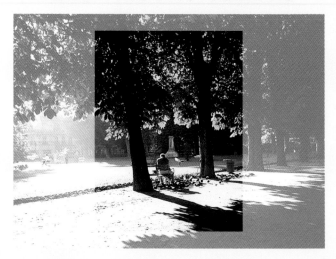

▲ The tracing is laid over a sheet of transfer paper placed face down on to the canvas or paper to be worked on. It is then retraced over the transfer paper, leaving a faint image on the canvas or paper underneath that can easily be covered by your subsequent painting.

TRACING THE IMAGE

Tracing is considered to be a form of sharp practice by many artists. In fact, it can be a very useful tool, as graphic designers and illustrators already know. The main advantage is time saving; if you can visualize an effect quickly by tracing you will be more tempted to try out several variations of a composition ,which may open up many new ideas. For example, a tracing of a figure from one photograph can be placed within another image providing a different background setting.

All of the elements of a composition can be traced on to separate sheets of paper, which can then be rearranged to improve or completely remake the composition. The individual tracings can be enlarged or diminished in a photocopier to fit the scale of the new image. You can also reverse a figure, or any other element, simply by turning the tracing over.

DIRECT TRACING METHODS

For tracing photographs that are light and sharp, a normal tracing paper can be used. Tracing paper comes in different grades and thicknesses, in pads or full sheets. If you plan to handle the tracings a lot while working out the arrangement of the image, use a heavier grade of paper as preferred by graphic artists, rather than the thin sheets ordinarily sold by stationers and general art suppliers.

Clear acetate is better for tracing dark photographs, as it may prove difficult to see the detail through tracing paper. You need to draw in felt-tip pen with permanent ink. Work from the top downwards to allow a few seconds for the ink to dry so that you avoid smudging the tracing as you work on it.

The one-sheet method of tracing down an image is by rubbing a pencil over the back of the trace, so that you have a thin layer of

A photocopy enlargement of your original photograph is much easier to trace and reveals shapes and tones more clearly.

graphite on the back that marks the paper underneath as you retrace. To keep the original tracing clean, you can make a separate graphite-covered sheet that you slip in between the tracing and the drawing paper; this should be usable several times. An alternative is to use commercially available transfer papers, which work in the same way as the intermediary tracing-transfer layer. The papers are thinly coated with powdery colour (several colours are available), which is pressed down on to the paper as you trace, leaving fine lines that are easily covered when you start to draw or paint over the traced image. The colour is also easily erased if you wish to amend the drawing.

Do not use the kind of carbon transfer paper intended for typing, as the carbon is impossible to erase and will show up through, for example, a watercolour wash, and may contaminate your paint colours.

USING PHOTOCOPIES

Tracing direct from a photograph will often present you with a problem of scale. Snapshot-type pictures are too small to facilitate the accuracy that you need; at some stage, the image has to be enlarged considerably to be useful for a painted composition. I recommend taking black-and-white photocopy enlargements and tracing from these. The copying process simplifies shapes and tones and, even though you work only in line, tracing from a photocopy can better reveal qualities of form and the pattern of light and shade. You can refer back to the original photograph for detail and colour as you progress with the painting.

Direct Tracing from a Photograph

This project shows a simple tracing transfer. Even the details of the cliff face were traced directly from the original photograph; nothing was changed in the composition.

The painting was made by the crayon and ink technique known as wax resist. I used oil pastels to draw over the traced image (wax crayons can also be used), then covered the drawing with thin washes of diluted coloured inks. The oily lines repel the watery colour, so the drawing shows clearly through the washed layers. This technique provides an image with an interesting combination of textures.

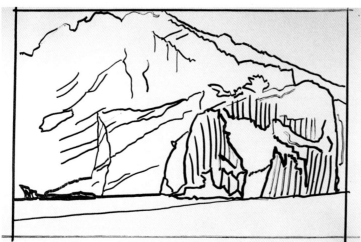

▲ The photographic source for the tracing was a slide, which was enlarged to an A4 colour print in a laser copier.

◀ STEP 1
The basic outlines of the cliffs were traced on to acetate from the laser print, with details of the rock textures also drawn in line.

◀ STEP 2
The tracing was enlarged in a photocopier and the image was transferred to the drawing paper using an intermediary transfer sheet. I made this by rubbing all over a sheet of tracing paper with a stick of graphite; a soft pencil such as a 4B or 5B would do as well.

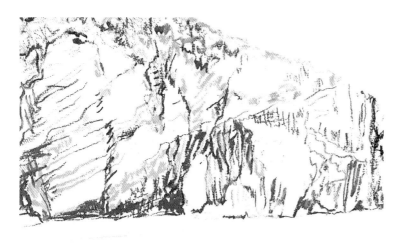

◀ **STEP 3**

The line drawing was reworked with oil pastels, using the coarse texture of the oil pastels on heavy watercolour paper quite boldly to represent the detail of the rugged cliff face.

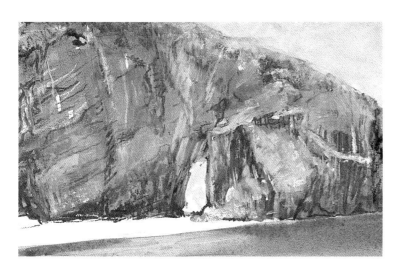

◀ **STEP 4**

Highlighting created with a white oil pastel showed up cleanly through a wash of blue ink. Pale pink pastel brought out the warmer tones of the rocks. I added viridian ink to the blue in the foreground while it was still wet, to give a soft, translucent effect to the sea.

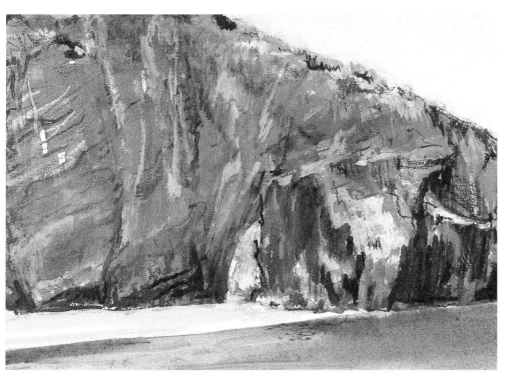

◀ **DIANA CONSTANCE**

Blue Cliffs
oil pastel and ink
225 x 355 mm
(9 x 14 in)
When the first washes had dried, I reworked with both oil pastel and ink to strengthen tonal contrasts — the dark blue shadows under the cliff, for example — and extend the colour variation.

TRACING AND PHOTOCOPYING

The photograph that inspired this painting was taken from the upper deck of a Greek ferry sailing to Paros. It captured the anticipation of the holiday-makers as the ship cut through the brilliant blue of the Aegean Sea. This was the feeling I wanted to express in the painting.

The image would have presented difficult problems of perspective and scale if it were drawn freehand. This method of tracing and making enlargements on a photocopier enabled me to get the drawing down quickly and try out variations. For example, having selected a group of figures from the photograph to make my composition, I later decided that the picture had become somewhat unbalanced and reinstated one figure that I had previously left out. It was easy to check that this would work by overlaying a photocopy of the figure on the drawing.

The unusual angle of the photograph framed the passengers against the sea. The composition is built out of the long curve of the lifeboat and the opposing diagonal lines of the ropes. The lower deck is also at a

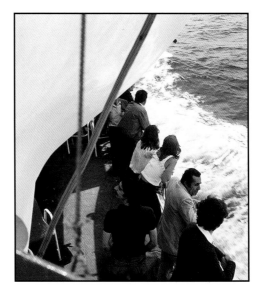

◀ Colour transparency of the ferry to Paros. From this, I made a colour laser print to enlarge the image to a suitable size for tracing.

sharp angle to the soft curve of the lifeboat. I decided to use simple, flat shapes in the painting to emphasize the abstract quality of the image. I chose to paint with gouache, a quick-drying, opaque water-based medium. This enabled me to overlay the paint and work in the small shapes quickly, without the problem of picking up colour from the paint underneath.

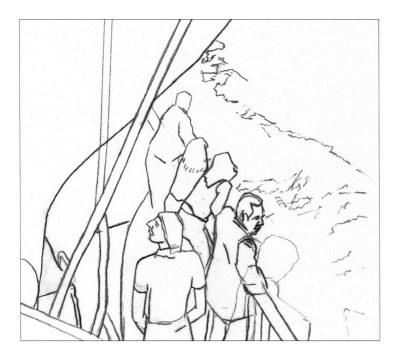

◀ This is the original pencil tracing in line. From this, the image was again enlarged on a photocopier. I also made a tonal study of the composition (above), shading the main shapes loosely with pencil, to look at the balance of light and dark in the picture.

◀ STEP 1

The traced image was lightly transferred to a sheet of watercolour paper and I began laying in free washes of gouache. At first, the picture was simply divided into light and medium tones of blue to hold together the composition.

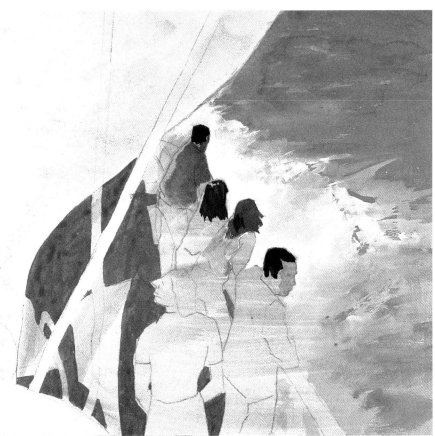

◀ STEP 2

Thick white gouache was laid in to outline the figures, and the high tone was pulled outward with a thinner wash to create the spray effect of the water. I painted in the flat, dark green of the deck, another important tonal key which also accentuated the figures.

▶ STEP 3

The figures were roughly
painted, varying colours
and tones just enough to
give a sense of form. It
was important to get
these colour relationships
right to establish the
overall mood of
the image.

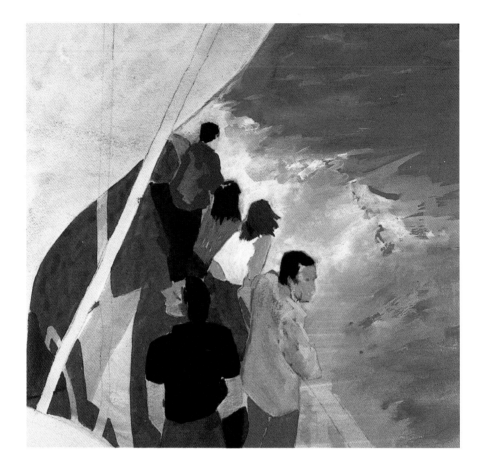

▶ STEP 4

With the basic colours of
the lower deck in place, I
could gauge the contrast
I needed for the lifeboat
hull and ropes. When
these were painted, I
returned to the figures
and adjusted the balance
of tones, creating more
intense light/dark contrast.

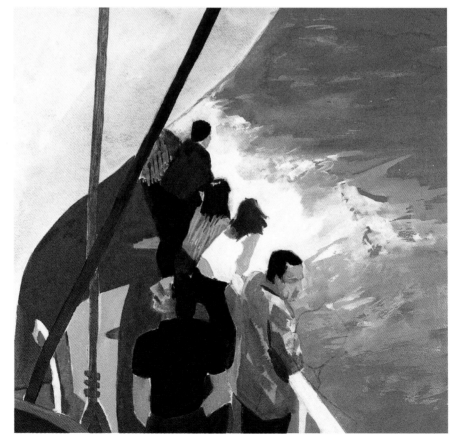

► STEP 5

Having eliminated the darkest figure in the foreground of the original image, the composition appeared too distant, pushed back from the lower part of the picture frame. I made a monochrome photocopy of the colour laser print, enlarged to the scale of my painting, and cut out the figure. I added the cutout to a copy of my enlarged tracing, to check its position and angle within the composition. I then placed the cutout on the painting, where it seemed to adjust the balance of shape and tone satisfactorily.

PROJECT

● **Choose one of your own photographs or a found picture from a magazine that you think will make a good composition for a painting.**

● **Enlarge the image as necessary and make a line tracing. Copy the tracing and shade it broadly with pencil to judge the tonal balance.**

● **Consider whether there is anything you want to take out of the picture or add to it at this stage. If so, rework the drawing and trace or photocopy the new version.**

● **Transfer your image onto paper using a transfer sheet or the scaling-up method. Paint it with gouache or acrylic paint, which are both opaque and easily built up in layers, working freely to develop colour, tone and texture.**

▲ DIANA CONSTANCE
Ferry to Paros
gouache
305 x 280 mm
(12 x 11 in)

In the completed painting, the diagonal line of figures draws the eye right through the picture from foreground to background. The variety of the figure poses, with the people looking in different directions, helps to suggest the excitement of the holiday mood that I wished to create, and this is also enhanced by a lively contrast of colours and tones.

COMPOSING FROM PHOTOGRAPHS

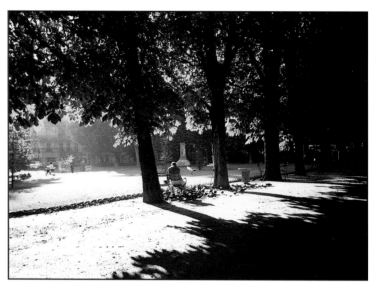

◀ This picture of the Luxembourg gardens in Paris, taken in late afternoon, caught my eye for the pattern of shadows cast by the trees and the dappled sunlight filtering through the leaves. Although its composition as a photograph in landscape format works well, a tighter, more concentrated image might work better as a painting.

Artists frequently refer to their photographs as visual notes, like drawings in a sketchbook. These visual notes contain a great deal of information, but it may not always be in the right place, or there may just be too much of it. A perfect photograph is the exception. However, once you develop the skills of working with photographs, it will open up a range of subjects that would be impossible without them, freeing your imagination and spirit.

To begin with, a photograph is not a complete picture of reality, but merely a split-second slice of reflected light set down in two dimensions. Unlike a sketchbook drawing, only limited pre-selection can be made when you are taking the photograph; whatever was in the scene has been faithfully recorded on film.

What you have is the raw material for a painting, presented in copious, confusing detail in two dimensions. As you begin looking at the photograph, you are at the same stage as a landscape painter who has just sat down, sketchbook in lap, and looked across at the field.

▶ Using a photocopied enlargement, I moved in closer to the central area of the image, emphasizing the trees and seated figure as the centre of interest. I cropped the photocopy to a vertical rather than horizontal format.

◀ The tracing of the basic shapes, including the pattern of light silhouetting the trees, forms a stronger composition. Transferring this simplified image to canvas or paper would give me firm guidelines for developing the painting, referring back to the original photo for details of colour and texture.

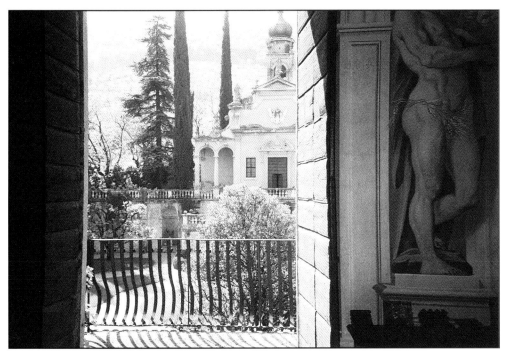

◀ This photograph of the view from a villa in Tuscany suggested a complicated painting. It seemed advisable to make a simple tonal sketch that would reduce the complexity of the visual information.

BEING SELECTIVE

Composition begins with the commitment to one certain part of your subject over the rest. You can select the centres of interest in a picture source in the same way as when working directly in front of the subject.

Selection and simplification are the key words when working from photographs. The elements of a photographic image can be moved around at will. Certain parts may be emphasized, enlarged or pushed back, and distracting elements can be eliminated. A photograph is seldom used without changing some part of it.

First, look for what I call the 'bones' in the basic composition. Photographs have a great deal of information, usually too much, and this can easily obscure a composition.

SIMPLIFYING SHAPES

If you want a quick method of checking the composition of a photograph, trace the outlines of the main shapes. Then put the tracing on a sheet of white paper and study the layout. This method reduces the picture to its most basic structure, so that you can identify its potential or its weaknesses. Once you have found a photograph with potential, you can start the preparation for developing your own image, using tracings

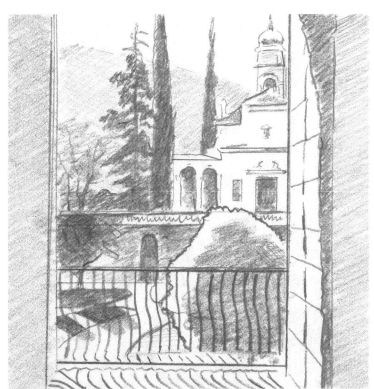

▲ The object of the tracing was to clarify the structure of the image for a painting, making changes as necessary. I cropped the sides of the picture, adjusted the line of the hill, and darkened the tall tree in the middle ground to give it greater contrast against the sunlit background.

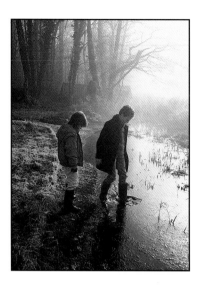

◀ Photographic source of *A Late Afternoon Walk* by Vanessa Whinney.

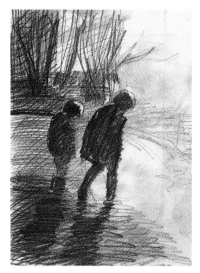

◀ A soft freehand pencil drawing identified the basic composition and tonal values of the work. The artist realized that the key to the painting would lie in expressing the mood, using the light to silhouette the children. She built up overlaid hatched and scribbled lines into dark tonal areas linking the figures and their cast shadows.

▶ **VANESSA WHINNEY**
A Late Afternoon Walk
pastel
330 x 225 mm
(13 x 9 in)
Soft pastel is an ideal medium for quick impressions of mood and atmospheric light. The artist has varied the texture of the pastel strokes, allowing the paper grain to show through in places, which has the effect of 'lighting' the mid-tones, but she has also built up the darkest areas solidly and thickly.

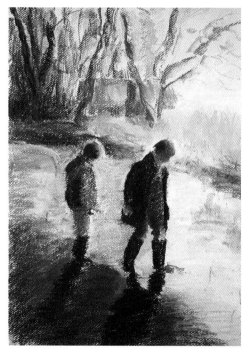

and photocopies to analyse the structure of the composition. Alternatively, you can sketch freehand from the photo to map out a painting. Next, look for changes you can make that improve the composition or focus it differently. These can include cropping the picture – changing the position and outer dimensions of the frame; adjusting the pattern of light and dark tones; or altering the scale of individual elements.

FREEHAND DRAWING

Drawing freehand directly from the photograph has the advantage of being extremely flexible and quick. Ask yourself what will be the centre of interest in the painting, and remember that the rest of the composition must enhance this.

Start by drawing the large shapes and the directions of these shapes in the photograph, not the details. You will probably wish to make changes; in general, photographs have too many mid-tones and not enough strong dark or light tones. As you draw out the composition, try to clarify the structure. By drawing quick freehand notes, you can make studies of a great number of photographs. In doing so, you can explore the possibilities of some of the less obvious pictures, which frequently turn out to be the most interesting.

PREPARATORY SKETCHES

Making a series of pencil sketches enables you to experiment with various approaches and changes in the composition. Determine at the outset exactly what your centre of interest will be. Use simple shapes for the main subjects of the composition. See how much detail you can eliminate – remember, less is best. Discover where the light is coming from in the photograph (see page 73). Make sure you lay in the highlights and shadows consistently. Draw the main shapes and use hatching or shading to put in a basic tonal plan. Look at the pattern the tones make with the drawing upside down. Treat this pattern as an abstract design and add to or subtract from it until it is pleasing in itself.

► Reference photos for *Crab Catch* by Sally Strand. These are 'snatch' pictures taken quickly to catch the action of the children.

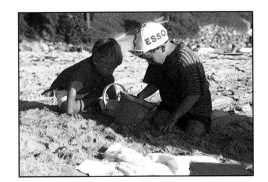

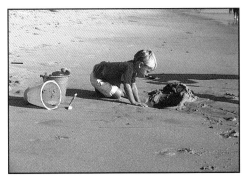

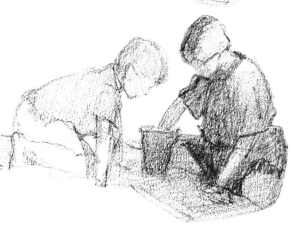

▲ **SALLY STRAND**
Sketchbook drawings for *Crab Catch*.
Although Sally Strand uses brilliant colours in her finished work, she first creates a strong tonal structure by interpreting her snapshots as a series of small pencil sketches. This enables her to try out several different versions of the composition, often combining parts of the image from a number of photos.

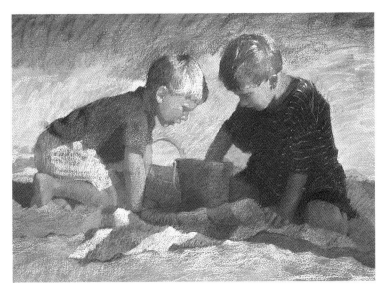

◄ **SALLY STRAND**
Crab Catch
pastel
510 x 760 mm
(20 x 30 in)
The artist uses the pattern of light and shadow to bind together the picture. She has adjusted the poses of the boys, drawing from her reference photos, to produce a concentrated, intimate moment. The coloration is underpinned by a firm framework of shapes and tones.

CHANGING FORMAT AND SCALE

When you analyse the individual elements of a photographic image, you may find that you wish to include most of the information in it, but not necessarily in the same relationships as in the photo. Moving, enlarging or reducing a particular feature can produce a much more satisfactory composition, in the painter's terms, even when the photograph itself seems more than adequate as a pictorial record.

The watercolour by Clifford Bayly shown on this page may at first glance seem to be a reasonably direct transcription from the photograph. The original image contained all the information the artist needed. However, you can see that a number of creative changes have been applied to the composition.

The first is the position of the boat. There is a general rule in painting that the focal area, or centre of interest, should not point beyond the edge of the canvas or paper. The change to the horizontal format, from the vertical arrangement of the original, opened up sufficient space for the boat on the right of the picture. The building in the background was cropped and the figure was diminished to make the shape of the boat more prominent.

The artist also dropped the distracting foreground details, such as the rope, the yellow board and the old tyre on the boat, to simplify and focus the composition of his watercolour painting.

▶ The artist's photograph of a dghajsa, the traditional Maltese fishing boat. The composition has a strong central axis, and no one element seems more important than another.

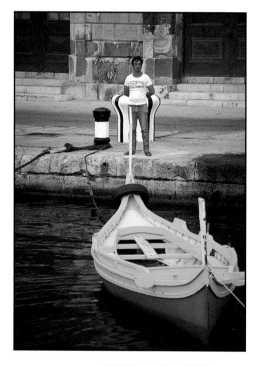

▶ CLIFFORD BAYLY

A Dghajsa, Vittoriosa, Malta
watercolour
305 x 430 mm
(12 x 17 in)
Repositioning the boat and the figure, together with cropping the top of the image, creates a different scale and perspective. The fluid watercolour technique gives a pleasing unity, but the artist has made the most of tonal and colour contrasts to enhance the position of the dghajsa as the clear centre of interest.

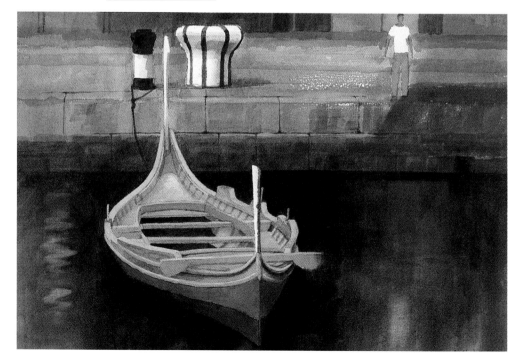

▶ Source photograph for *White Towel* by Sally Strand. This was a quick snapshot, intended to record a certain gesture and momentary mood. The picture has good light and tone, but the main elements of the boy, the woman and the beach accessories are somewhat disconnected. The red bag makes a too-bright splash pulling away from the figures and out of the picture frame.

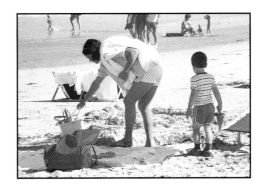

◀ **SALLY STRAND**
White Towel
pastel
280 x 355 mm
(11 x 14 in)
The artist has found a tighter composition by turning the boy and moving him closer to the woman. The figures fully occupy the centre of the frame; other features have been rearranged to fill out the image. The tonal balance has been carefully organized, with excellent judgement of low- and high-key colours. A curve of white light travels along the towel, down the side of the boy and on to the blanket, connecting all the elements of the picture.

FOCUS ON FIGURES

It is natural for the viewer to seek out the human content of a painting . Where a figure or figure group is included, that gives us a point of identification, more so than any inanimate objects in the scene or the general surroundings. In some photographs, the figure naturally appears as the focus of interest but may seem incorrectly placed; in others, the organization of two or more figures may not work to advantage.

One of the best reasons for using photographs is the ability it gives you to make the changes you need. You can trace off the elements you want to keep and rearrange them. A figure, or figures, can be enlarged, diminished, reversed or multiplied at will by tracing and photocopying. You can also use photocopies to create a montage, a combination of photographic elements, that enables you to adjust the scale, position or orientation of a figure within the view. An alternative is to draw freehand sketches that serve the same purpose of developing a different interpretation of the composition.

►This holiday snap suggests an attractive painting, with the austere, brightly lit facade of the hotel standing tall behind the seated figure. However, the figure is too small and seems almost incidental.

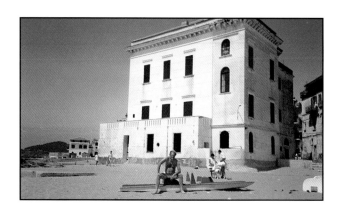

► I made two black-and-white photocopy enlargements of the image at different sizes. From the larger of the two, I cut out the figure seated on the slender boat and pasted it into the foreground of the first photocopy.

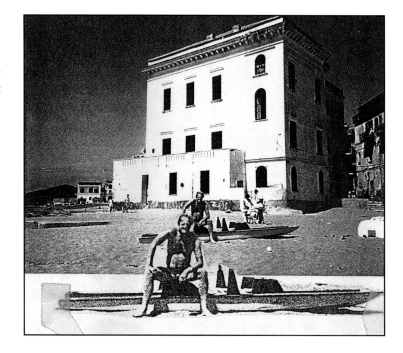

◄ The tracing from the photocopy montage gives the figure a more prominent role. The tonal distribution of the image is also more balanced overall, with the darker shading on the boat and figure occupying a greater extent of the foreground.

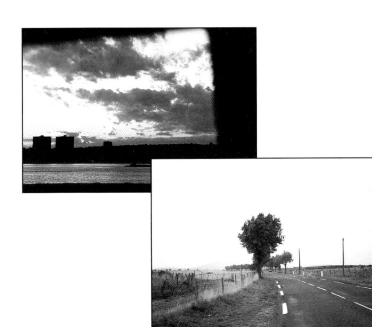

CHANGING THE BACKGROUND

Artists frequently simplify the background of a photographic image when translating it to a painting. Eliminating background detail helps to direct all attention to the centre of interest. But the background can contribute a lot to the mood of the picture. Exchanging a large part of the original image for something more dramatic can bring life and interest to an otherwise dull image.

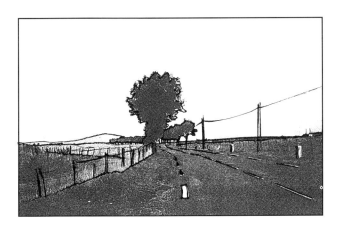

◄ This photograph taken in France on an overcast day (left) seemed dull and uneventful, but the idea of combining it with an exciting cloud effect from a snapshot taken in the USA (above left) gave it potential as the basis for an interesting painting.

▲ The landscape photograph was enlarged as a photocopy and traced over to isolate the foreground elements.

▲ The US photo was separately photocopy-enlarged to magnify the cloud effect.

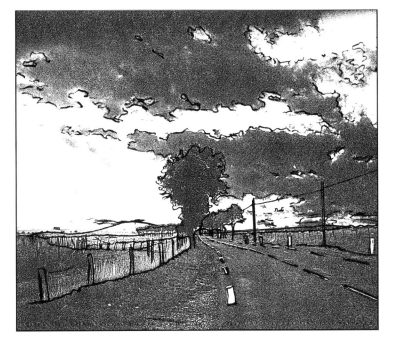

◄ The tracing of the road and tree was placed over the sky photocopy and moved around to find the best position. Then the cloud outlines were traced to create one unified drawing for the whole composition.

RE-CREATING A SETTING

In this project, the confusing mass of birds in the source photograph does not prepare us for the elegant painting it will become a part of. The individual shapes of some birds were of interest; the main problem was the background, which was too close to the birds in both colour and relevant space.

The artist had other photographs of the same type of terrain, but taken from a higher viewpoint. By re-creating the background, he enabled the birds to fly above a beautifully composed landscape that contrasts with and complements the birds' shapes and colours. The horizon is our eye level as we look at the picture, so we seem to be looking down at the birds. Without the help of photographs, the artist would have found it difficult, if not impossible, to make the associations that brought this 'leap' of creative imagination.

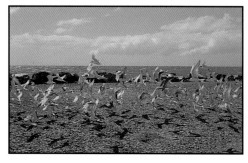

◀ Source photograph of the terns, taken from ground level.

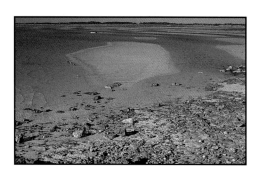

▲ Source photographs of Moonta beach, taken from a high viewpoint which raises the horizon line.

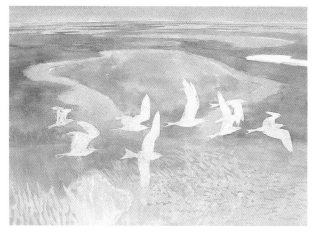

▲ STEP 1
The beach and the birds were lightly sketched with pencil, then thin watercolour washes were laid into the background. The shapes of the birds were 'dropped out' — that is, not painted in at this stage.

▶ STEP 2

The sky and far distance were established by strengthening colour and tonal contrasts. This stage of the work greatly enhanced the picture depth, though still dealing in simple shapes rather than exploring detail.

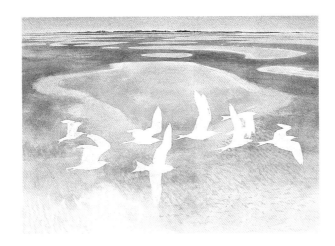

▶ STEP 3

The artist chose to make the ripple marks in the sand a crucial part of the composition. The lines describe the gentle curve of the earth, which would only be apparent from high altitude, helping to establish in the viewer's mind the height of the birds' flight.

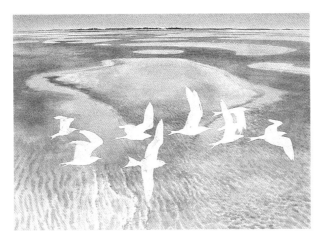

▶ CLIFFORD BAYLY

Terns at Moonta Beach
watercolour
455 x 610 mm
(18 x 24 in)
With the background space realized, the terns were painted in, leaving bright highlights of bare white paper to show how the sun caught their wing tips high above the beach. The painting was given an overall weak 'glaze' of yellow watercolour at the last stage to create a gilded quality of light.

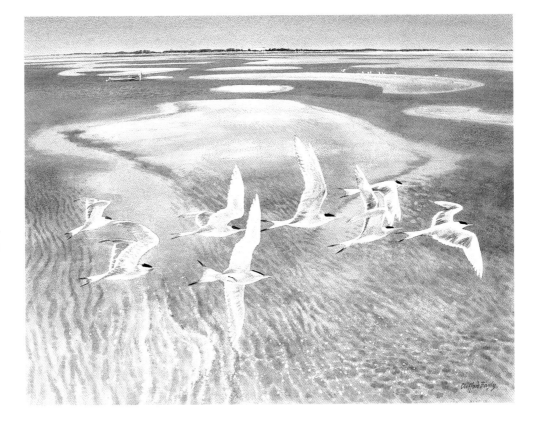

COMPOSING FROM PHOTOGRAPHS

COMBINING PHOTOGRAPHIC ELEMENTS

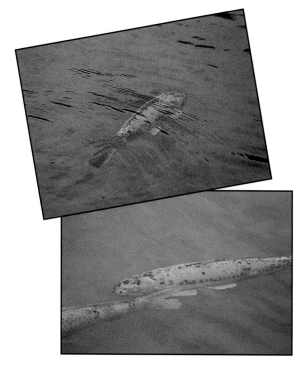

This painting is a straightforward example of combining images from several photographs by the tracing method. The artist photographed the carp in their outdoor pond on a numbingly cold and windy day. In this situation, the painter has a great advantage over the photographer, who would have to wait for hours to catch the carp in a reasonable light and composition. The artist, on the other hand, could simply walk around the pool taking photos of the individual fish, then return to his warm studio to work out the composition at leisure.

Because the photographs were dark, the tracings were made on clear acetate. The fish shapes were cut out and moved around on a white background to work out a good composition. Once the artist had settled on the layout, he taped down the cutout shapes and retraced the fish in position.

◀ Source photographs of the carp. From these, the artist developed two separate compositions.

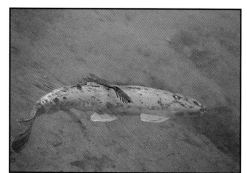

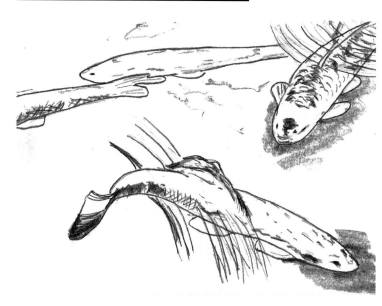

These tracings (left and above) of the final compositions were arrived at by first cutting out the fish shapes, then arranging them on paper and retracing.

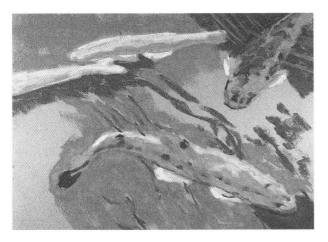

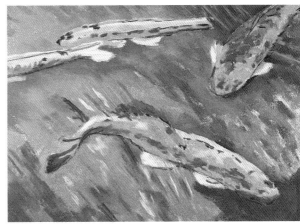

▲ STEP 1

The tracing was transferred to pastel board by putting a transfer sheet between them. The movement of the water was not well defined in the photographs, but was an essential feature of the pastel composition. The artist began with free, bold strokes defining basic colours and tones.

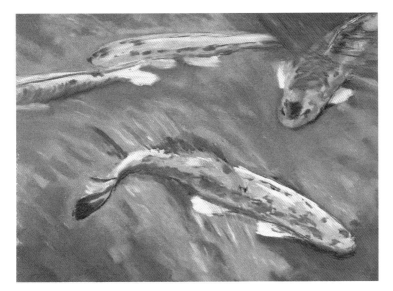

▲ STEP 2

By gradually increasing the range of his pastel colours, keeping the same free drawing technique, the artist built up the impression of movement and light, emphasizing the rippling pattern of the water against the bright markings of the carp.

▲ DAVID POOLE

Golden Carp: first version
pastel
355 x 480 mm
(14 x 19 in)
The fish swim together very naturally. The artist used his visual memory of the carp pond to supplement the photographic reference, building up a rich, movable surface layer with the soft pastels.

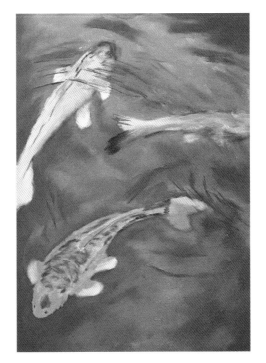

◀ DAVID POOLE

Golden Carp: second version
pastel
480 x 355 mm
(19 x 14 in)
In this pastel painting, as in the first, the fish move in all directions, causing the viewer's eye to roam freely around the composition picking up points of light and contrast.

MAKING A MOSAIC

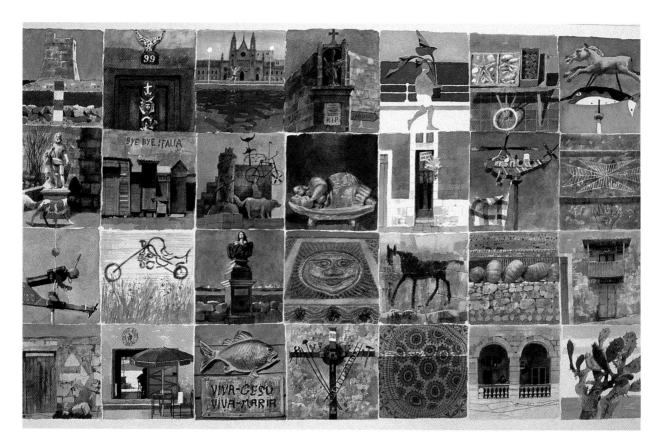

Photography gives us many possibilities in composition. The painting does not have to be limited to one or two images, nor does it have to be static. The mosaic shown here is composed of 28 different paintings taken from 28 different photographs.

A mosaic is an exercise in pure design. Although each section is a separate painting, the shapes and colours of all the pictures are balanced. The warm, sunlit, earthy colours are complemented by cool blues and greens that move the eye around the composition. There are changes in space and depth, from a close-up view to a distant perspective. The artist chose varying angles of perspective to refocus our attention; for example, the green doorway contrasts with the pictures on either side, which were taken from a distance. This shifting scale continues to recur. Some of the images are painted directly, while others are radically changed.

SELECTING AND COMPOSING

Although a mosaic is made up of a great many images, it is still one painting, needing a linking theme. The composition can be loosely based on any subject. Six or more pictures are needed to begin with and if the small paintings are done on separate pieces of paper, the mosaic can 'grow'.

Use a methodical approach for assembling the pictures. When you are satisfied with your arrangement tape the pictures in position on a board, so you have permanent reference for your painting.

A water-based medium is best for this kind of small-scale work. Keep the paintings simple, emphasizing shapes and colours rather than details. I suggest working the images on individual pieces of paper, rather than all on one sheet: that way, if something does not work you can replace it, or you can add to your mosaic at a later date.

▲ **CLIFFORD BAYLY**

Malta Mosaic
watercolour
455 x 760 mm
(18 x 30 in)
Punctuated with dark tones and graphic imagery, this witty, multitudinous mosaic expresses the life and culture of Malta in a way that one large landscape picture could never do. The images form a kaleidoscope of memories from the artist's Maltese visit, including the kind of lively, quirky details of everyday activity that are often overlooked.

PROJECT

● Use one roll of print film with 36 exposures to photograph a special theme. Select a 200 or 400 ASA film, using the higher ASA number (faster film) if your subject is in poor light.

● Reserve one-third of the shots for details. Try to find some interesting lettering or other graphic image that contrasts with three-dimensional qualities in the broader views.

● Have the film roll developed and enlarge each print in a black-and-white photocopier to A4 size.

● Select and compose the colour prints into a mosaic of at least six or eight images.

● Select and compose the photocopies into a mosaic.

▲ Source photographs for *Malta Mosaic.*

49

INTERPRETING THE PHOTOGRAPH

There is a great difference between copying a photograph and using one creatively. By their nature, photographs are easily accessible, and they also possess a great deal of visual authority, which can be intimidating when you begin using them.

You do not have to accept everything in a photograph for your painting. As an artist, you have total discretion to change the image, add to it, or discard anything you feel is unsuitable. If the sky is grey, you can change it to a brilliant blue, orange, or whatever. The painter's creativity is paramount, and remains so whether you are working from a photograph or painting directly from the subject.

RE-CREATING THE PHOTOGRAPHIC IMAGE

Even if you intend working closely to the photographic image in your paintings, it is useful to do a few exercises that help to free you from a too literal interpretation. The first attempt at using a new photograph is always a bit tentative – you need to find your way into it. I have often found that by the time I complete a painting, I am just beginning to realize what I should have done in the first place. For this reason, I always do several paintings from one source. It takes time to focus on anything, and there are a number of valid interpretations of one subject or one image.

Each time you paint from a photograph, you will increase your confidence in using it freely. You can refer back to the photograph for your second or subsequent attempts at the subject; or you can put the original picture away and use your first painting as your reference material for the next, much the same way as you might use a sketch.

This provides a distance between you and the photograph. The displacement of

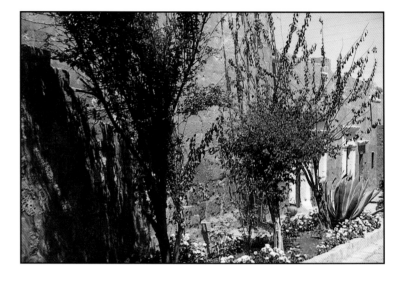

the original with your own work usually leads to a better second painting.

The pastel drawings on these pages are student exercises designed to find ways of freeing the interpretation from the 'tyranny' of the photograph itself. Pastel is an excellent medium for free colour work – quick and direct; but you can choose to leave the pastel image as an early impression or to push it forward, building up the colour and developing the layers. That way, you can include any new and expressive details that emerge as you study the photograph, or rework parts of the drawing that did not succeed initially.

If you are working from your own photographs, you may also find that a series of paintings leading you away from the original source picture helps to revive memories of the mood or sense of place that you absorbed at the time.

▲ Source photograph of the exterior of a convent in Chile. The composition is not ideal, as the picture is cut off in the foreground, but the slanting perspective of the trees and other plants leading away from the dark shadow against the convent wall suggests an interesting image.

▶ A quick freehand sketch was made in felt-tip pen to adjust the perspective, lowering the eye level and pulling back the view so that the trees and pathway are raised up from the bottom of the frame.

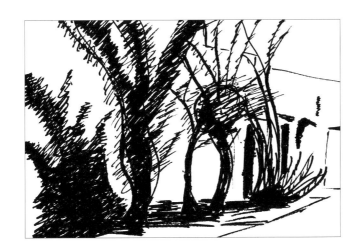

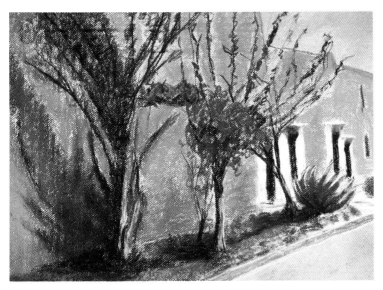

◀ **FREDA COWELL**
The Convent: first version
pastel
250 x 330 mm
(10 x 13 in)
The artist was drawing directly from the photograph, but adapting the shapes to the revised composition. The colours she chose were relatively naturalistic, but with a more emphatic contrast of light and dark.

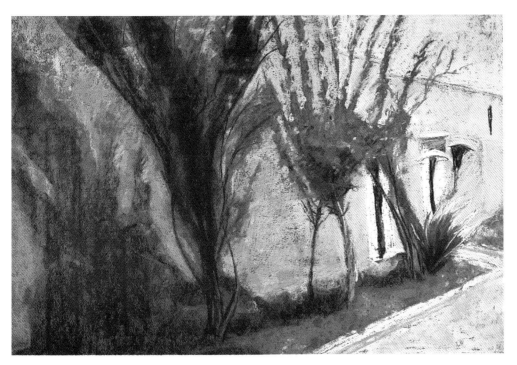

◀ **FREDA COWELL**
The Convent: second version
pastel
250 x 330 mm
(10 x 13 in)
The second colour sketch was done using the first as the reference, without looking back to the photograph. The artist chose a green-tinted paper to give body colour for the drawing. The pastel colours were developed more imaginatively to interpret the warm light.

SIMPLIFYING THE REFERENCE

Another way of encouraging your creativity is to work from a black-and-white photocopy instead of a colour print. The simplified image of a photocopy, which reduces the detail as well as removing colour reference, gives greater scope for your interpretation of the subject.

The three paintings shown here were student exercises based on a photocopy of a postcard from Greece. By emphasizing the tonal structure of the image – the light rather than the colour – the copy highlights the dynamic arrangement of the architecture. The pastel pictures are very different but equally interesting developments of this basic framework. They show how aspects of composition, colour and light can all be interpreted expressively from relatively minimal information in the photographic source.

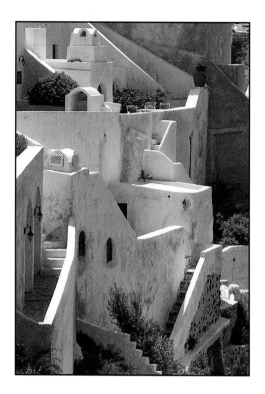

◀ The original postcard from which a photocopy was made to provide a simplified image.

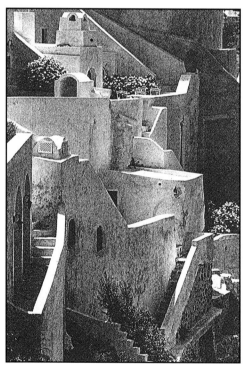

◀ The photocopy made from the postcard. When the colour cast of the light is eliminated from the image, the complex pattern of light, medium and dark tones is easier to define.

▶ FREDA COWELL
Santorini
pastel
405 x 305 mm
(16 x 12 in)

This artist chose to make two pastel drawings from the photocopy, changing the colours to suggest different times of day. In the first (right), she cropped off the top of the image and selected a palette of warm colours expressive of sun and heat. Both the cropping and the colour values draw the viewer into the scene.

In the second pastel (far right), she returned to the perspective of the original image. The cool palette of blues with neutral black and white to heighten tonal contrast creates a calm, moonlit effect.

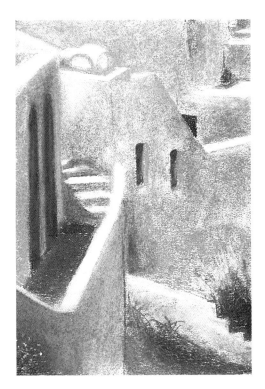

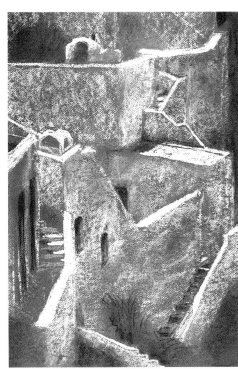

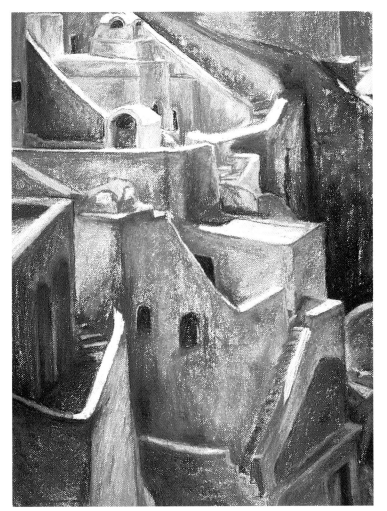

◀ CONNIE WANG
Greek Postcard
pastel
635 x 510 mm
(25 x 20 in)

A fascination with the sculptural qualities of the buildings was the basic motive for this interpretation. Connie Wang chose a large sheet of rough watercolour paper to work on, using the way its heavy grain breaks up the pastel colour to express the textured surface of the walls, with the light reflecting from flat planes and sharp angles. She built up several colour layers and developed a strong contrast of tones to bring out the forms clearly. The direction of the light was maintained throughout, giving the picture a sense of space and three-dimensionality.

FREEING YOUR COLOURS

Since a photograph of a landscape will not change with the weather or fade in the evening light, the painter has time to experiment with it and use it in different ways. This landscape based on the Cévennes in south-western France is a good example of using the bare bones of a photograph as material for free expression.

The photograph was taken when the light was dull and flat, which I knew would make an uninspiring picture but I did not have time to return another day, and the actual light effect was not the point – I just wanted to record the shapes in the landscape for further use. Back in my studio, this rather dull photo became the matrix for

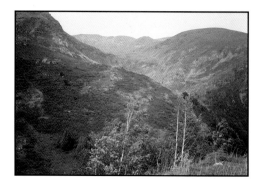

many experiments in pastel and paint. The pastel drawing sequence shown here was an experiment with using brilliant colour to enliven the overall view and enhance the powerful pattern of interlocking shapes.

◄ Enlarged colour copy of the original photograph. This gave me a more fluid, detailed impression of the contours of the hills.

▼STEP 2
The first colours were laid in loosely using the sides of the pastel sticks to sweep the pigments broadly over the neutral ground, redefining the main parts of the composition.

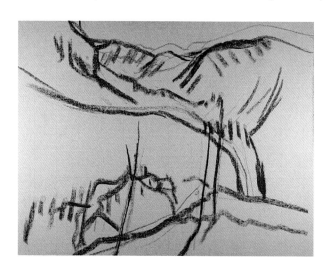

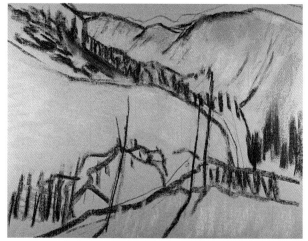

▲ STEP1
I chose a fairly light-toned, neutral buff paper and began by drawing the basic shapes freehand with a stick of charcoal. I adjusted the photographic composition by extending the foreground area and giving those shapes more prominence.

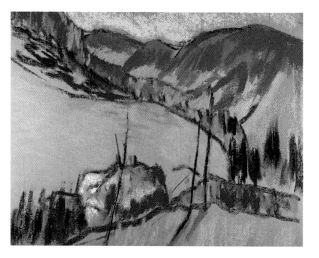

◄ STEP 3
The light was behind the hillside and I applied a brilliant yellow to the sky above deep ultramarine and cobalt blue on the far hill. The colours that were in the landscape were greatly intensified in the pastel, rather than completely changed.

▶ STEP 4
After laying in warm terracotta to create the flow of the left-hand slope, I darkened the middle ground behind it, which was partially in shadow below the mountain ridge. This tonal adjustment also helped to bind together the composition.

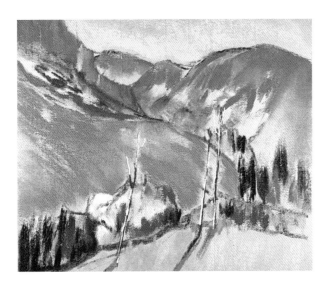

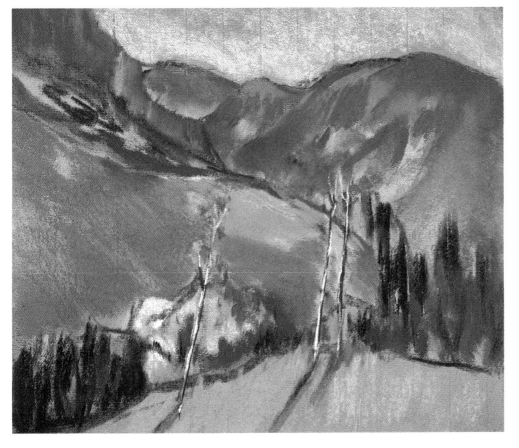

▲ DIANA
CONSTANCE

*Late Afternoon
near Florac*
pastel
420 x 495 mm
(16½ x 19½ in)
A strong patch of light at the centre of the composition balanced the intensity of the yellow sky and gave the picture more luminosity and depth.

PROJECT

● **Choose a photograph of a landscape with a strong composition and clearly defined shapes.**

● **Make a tracing of the photograph and transfer it to tinted pastel paper, or sketch the composition directly on to the paper.**

● **Draw the outlines of the shapes with a neutral-coloured pastel or a piece of charcoal.**

● **Choose a palette of colours that are bold and vibrant, but basically suited to the subject. For example, a tree can be emerald or leaf green with a burnt sienna or coppery trunk, against a sky of cobalt blue. Try out the colours on a separate piece of paper to see how well they work together.**

● **Lay down the basic colours broadly within the drawn shapes. Work over the whole of the composition, leaving the details to the last.**

● **Add highlights with touches of bright colour and strengthen the shadows to develop the contrast.**

USING YOUR MEDIUM

Your choice of medium can radically affect the way you interpret a photographic image. Each kind of drawing or painting material has its own particular qualities of tone, colour and texture that contribute in large part to the character of the finished work. However, any medium is also quite versatile, as you can see from the ways artists can make one type of paint achieve different qualities of finish and pictorial depth, according to their own style and intentions in the work.

When you look at a photograph as a basis for a painting, consider one of two things: either, how can the qualities in the paint medium you want to use be creatively applied to the visual information in the photo; or, what are the specific features of the photographic image that might suggest its suitability for interpretation in one medium rather than another.

DRAWING MATERIALS

Drawing is often your first or intermediary stage towards the full composition taken from a photograph. Pencil is a familiar and extremely sensitive medium, which is adaptable to different styles of drawing and easily erased to correct mistakes, so it is likely that you will have an instinct to begin work in pencil.

Choosing an alternative drawing medium can, however, help to free your technique and approach. The more direct, bold materials, such as charcoal, crayon, graphite sticks and even felt-tip pens, may help you to produce a more broadly interpretive impression of your photographic source.

WATERCOLOUR

This is the purest and most delicate of the paint media, basically consisting of pigments suspended in gum. The finest qualities of watercolour are its luminosity and depth, because the paint is translucent and the white of the paper glows through the colours. This same translucency can make it difficult to work with, however, as errors cannot easily be covered up as they can with an opaque paint.

The basic technique of using watercolour is to build up colour and tone with successive thin layers – washes of diluted paint. It takes time to learn to control the washes, anticipate drying time, and develop techniques for introducing detail. Traditionally, too, you have to be able to 'reserve' the white of your paper to make any highlights; it is possible to add highlights later with opaque white (body colour or gouache), but you cannot then successfully paint over them with watercolour if you decide to make changes, as the chalky pigment will pick up into any washes overlaid on it.

GOUACHE

This somewhat neglected medium is more often used by designers and illustrators than by painters. When you are using it for finished pictures, you need to check the permanency of colours in the range you choose, as some pigments are fugitive and

▶ Charcoal

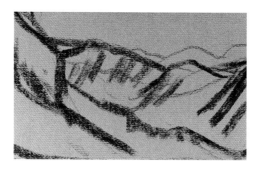

▶ Watercolour

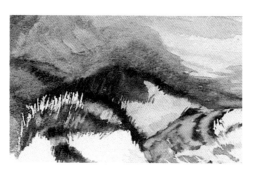

▶ Gouache

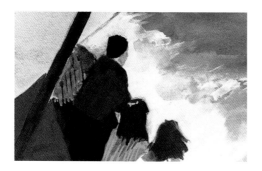

will fade over time. However, there are distinct advantages to using gouache: as a quick-drying, water-based, opaque paint, it is easy to handle; you can build up paint layers very rapidly and overpaint as much as you like. The colours are bold and bright, so you can obtain very intense contrasts of light and dark.

PASTEL

Soft (chalk) pastels or oil pastels give you a very direct method of applying colour quickly. Soft pastels are almost pure pigment, with only enough binding medium added to enable the colour to be rolled into stick form, so this is a very intense and vibrant medium. There are many different soft pastel brands and a vast range of colours to choose from, including graded pale tints of the pure hues.

The most effective way of working with soft pastel is on a grainy, tinted paper. A coloured ground means that you do not have to build up solid layers of applied colour, though a paper with a good 'tooth' means that you can go on adding colours and making changes, and you naturally obtain interesting textures from the interaction of pigment and paper surface.

Oil pastels are moist and the painted surface remains continuously workable. There are far fewer colours in oil pastel ranges than in soft pastels, but more than enough to enable you to select a suitable palette to work from.

ACRYLIC PAINT

Acrylic paint is pigment bound in a synthetic 'plastic' resin which dries to a resilient, non-water-soluble finish. But acrylics are convenient to work with as you mix and dilute them with water. Some colours are more translucent than others, so you can work with solid, opaque colour or thin washes. A potential problem with acrylics is that the paint is very fast-drying and completely immovable once dry. This takes some getting used to for the working process – for example, your brush marks may remain clearly visible in a heavy application of paint. But the fast drying has

◀ Pastel

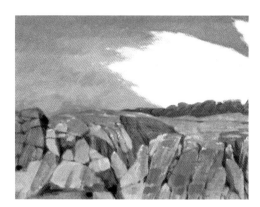

◀ Acrylic paint

the advantage that you can easily overpaint to make changes. Unlike watercolour, however, you can lay washes over opaque paint without any pick-up.

There is a large colour range which now includes metallic and pearlized paints. The surface finish is rather glossy, hard and 'artificial' as compared to watercolours or oils, but interesting textures can be achieved.

OIL PAINT

Oils are unbeatable for richness and depth in a painting. The main disadvantages are the very slow drying of the oils in the paint, which makes overpainting difficult until you get used to the medium, and the fact that you have to use a prepared surface to paint on a primed paper or canvas, or a prepared canvas paper or board.

The colour range of oil paints is vast, and surface textures can vary from light glazes of colour, thinned with turpentine, to smooth blends to thick impasto brush or knife strokes. Because of the slow-drying quality, you have to build up from thin to thick – the last layers or glazes of oils must be mixed with linseed oil so that they will stretch and not crack as they dry; and the thicker the paint, the more drying time it needs.

▲ Oil paint

TONAL VALUES

Frequently, there is confusion about the meaning of tones, or tonal values. Put simply, tone is the amount of lightness or darkness in a colour. It is above all the key element in composition and working from photographs; tones provide a firm structure for a painting. In colour photography, the true tonal balance or darkness of the colours is compromised. The artist must work to restore this in the painting.

Dull photographs can be transformed by enhancing the tones in the painting. Conversely, a strong photograph can be wasted if the contrasts between light and dark areas are not carried through in the painting with resolution and courage.

DEFINING TONAL STRUCTURE
Seeing or distinguishing the tonal structure of a photograph is quite simple if you have

▶ **BARBARA JACKSON**
A Large Tree on the Heath
gouache
250 x 200 mm
(10 x 8 in)
The artist mixed only four tones from black and white gouache to create this stunning painting, in which the tree has a stark, monumental presence. The opacity and fast-drying quality of gouache make it a useful medium for tonal studies, as you can quickly build up dynamic contrasts.

▲ The source photo, which is an enlarged colour print, for the tonal studies of *A Large Tree on the Heath* by Barbara Jackson.

◀ **BARBARA JACKSON**
A Large Tree on the Heath
crayon and India ink
250 x 200 mm
(10 x 8 in)
This effect was achieved by drawing with a white wax crayon to reserve the highlights, then painting over with ink wash, heavily diluted to make the pale tones. Pure black ink and dry-brush techniques were used for the rough texture of the tree bark. The translucence of the washes in the more active background creates a soft, inviting mood compared to the gouache painting.

access to a photocopier. Have a black-and-white enlargement of your colour print made, which will give you an instant tonal picture of the image from which to work. Most artists painting from photographs use this device.

If you want to gain a better understanding of the structure of a colour print or its photocopy than you would have just by looking at it, make a tracing of it. Draw in the basic shapes, the main outlines and areas of strong light or dark, then identify the tonal structure by crosshatching the areas of tone. You can keep this quite simple, using, say, one or two tonal values to represent dark and mid-tones.

When you have finished the traced drawing, lay it on a clean sheet of white paper to see how it works. Changes can easily be made at this stage before the whole composition is transferred to your paper or canvas.

In addition to, or in place of, the tracing, tonal studies can be made in any medium. They can be very attractive works in their own right, or preliminary drawings for full-colour paintings.

SPACE AND MOOD

Working with tones leads us directly into the expression of space on the two-dimensional surface of paper or canvas. The general rule is that deeper tones appear closer to us and fainter tones recede. The degree of contrast between light and dark tones also affects the spatial arrangement of the image. There are other elements that create space in a drawing or painting, but the importance of tonal values should not be underestimated.

Tone can be used to develop mood and drama as well as structure. The more contrast between the tones, the greater the dramatic impact of the composition. Soft contrasts in a winter landscape, for example, tell us that the sky was overcast. The same landscape in summer sunlight has sharp tonal contrasts, often exemplified by very dark cast shadows from upright features such as trees and fencing, or from undulations in the shape of the land.

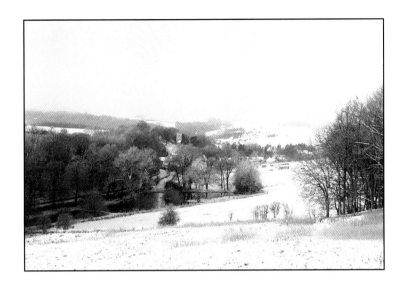

▲ Source photograph for
Snow – Compton Abdale
by Donald Cordery.

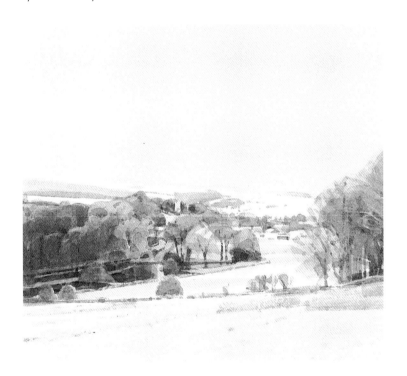

▲ DONALD CORDERY

Snow – Compton Abdale
watercolour
255 x 265 mm
(10 x 10½ in)
There is a very subtle colour combination in this picture, but the landscape is essentially monochromatic. The apparent range of 'colour' variation is in fact due to changes of tone. The artist has built up washes of different intensities to layer the landscape detail in the middle ground, with only the faintest wash across the background – almost no more than 'dirty water' – allowing it to fade back into infinity.

TONAL DEPTH

This is an example of creating space and depth in a landscape painting by employing a basic range of tones. The stronger the contrast in tones between the foreground and background, the greater the impression of space between the two. The same principle could be used in, say, a portrait or still life to 'push back' the surroundings and give greater focus to the figure or objects.

Working on toned paper is a traditional pastel technique. When you are relying on tonal range to create structure and balance in a drawing, the paper colour usefully establishes a middle tone from which you can judge the extremes of light and dark contrast. Using a limited palette was effective here, first developing the landscape shapes and pattern in black, white and grey, then adding minimal touches of colour to enhance the mood.

For this kind of rugged landscape, the strong texture of pastel is appropriate. Although a dramatic change in the drawing came from blending some of the tone and colour in the final stage, most of the work was built up with direct strokes, using the tip and side of the pastel sticks.

▲ The photographic reference was two colour prints, overlapped to extend and improve the composition, from which an enlarged black-and-white photocopy was made.

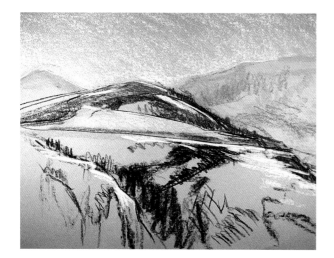

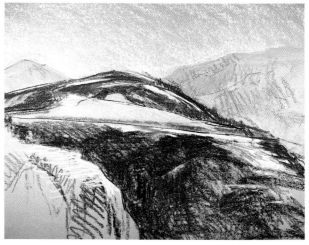

▲ **STEP 1**
The composition of the basic shapes was drawn freehand and adjusted to create a greater impression of space. I have pushed back the far hill and increased the depth of the foreground, accentuating its curve.

▲ **STEP 2**
The foreground plane was brought forward and isolated from the middle ground by an application of very dark tone, contrasted with the pure white highlight on the curve of the hillside to the left.

▶ STEP 3

Gradually the tones were strengthened over the whole of the drawing. I used the textures and directions of the pastel marks to emphasize the individual elements of the landscape.

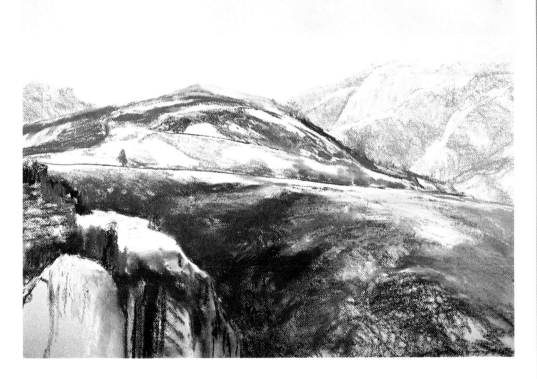

▲DIANA CONSTANCE

Landscape in the Cévennes
pastel
550 x 725 mm
(22 x 29 in)
A contrast of warm and cool colours, as well as tonal values, similarly helps to define depth in landscape. I laid in soft side strokes of yellow ochre and raw sienna across the foreground and blended the tones and colours gently. These warm tints gave greater cohesion to the swelling bank of land on the right and greater impact to the dark cleft in the hillside.

PROJECT

● Choose a black-and-white photograph with simple shapes.

● Enlarge it to at least A4 size in a photocopier.

●Make a tracing of the photocopy and transfer it to a sheet of cartridge paper.

● With a hard (HB) pencil, crosshatch all the parts of the composition that should be in light tone, leaving any white areas blank.

● Pick out the mid-tones by crosshatching those areas with a softer pencil (B or 2B).

● Repeat the process as often as is necessary to build up all the important tones in the picture, finishing with a true black (4B or 6B).

BALANCING TONE AND COLOUR

A clear sense of tonal structure is invaluable for helping you to organize work in full colour. In both of the examples on these pages, the artists have used the pattern of tones to underpin the colour relationships and impression of light.

In the image of the church in Cyprus, the dominant element of the composition is light, with the pale, round dome set against the dark diagonal of the hillside. Paul Watkins made his monochromatic study in burnt sienna (tonal drawings do not have to be black or grey), using diluted washes of the one colour. The strong tonal contrasts create the appearance of bright sunlight, appropriate to the light of Cyprus. As a rule, the stronger the contrast, the more a scene appears to be sunlit; softer contrast gives the impression of dull or poor light.

For the finished watercolour, the artist followed his tonal study quite closely and maintained the range of tonal contrasts, though the broader colour palette naturally gives the work a different mood and more fully describes its setting.

▼ The source photograph of the Cyprus church was a transparency. The artist had a large colour laser print made from it, which was easier to work with.

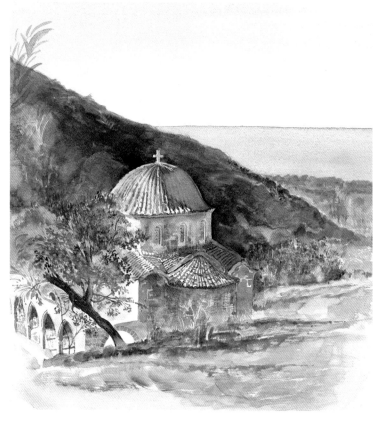

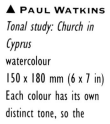

▲ **PAUL WATKINS**
Tonal study: Church in Cyprus
watercolour
150 x 180 mm (6 x 7 in)
Each colour has its own distinct tone, so the choice of burnt sienna for the monochrome study lifts the overall tonal key, as compared to the way the painting would appear if it had been painted in tones of black.

▲ **PAUL WATKINS**
Church in Cyprus
watercolour
255 x 305 mm (10 x 12 in)
The church itself is still mainly defined with a tonal scale of burnt sienna, modified with Payne's grey, which gives the artist a key directly related to the monochrome study. In the surrounding landscape he has fully developed the range of colours that describes the particular location, contrasting the warm burnt sienna with cool blues, yellow-greens and umbers.

▶ In this colour print of the Cordoba landscape, the exciting pattern of fields and hills suggests a strong image, but the tonal contrast is faded and low key, except in the immediate foreground.

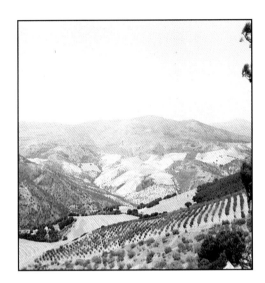

◀ **ALISON DUNHILL**

Landscape near Cordoba
oil
1220 x 1070 mm
(48 x 42 in)
The attractive patchwork of the view is strongly defined with dark lines and shapes. The artist has used both thin oil glazes and thick, opaque colour to create the medium and light tones. The overall heightened contrast gives a brighter, more dynamic impression of the summer mood.

Alison Dunhill's photograph of a vast panorama near Cordoba in Spain was taken with the intention of using the picture later as studio reference. When constructing the painting, she improved the composition by raising the horizon line. As the horizon line corresponds to our line of sight, this created an interesting downward view into the landscape. The hills had to be stretched out to accommodate the new perspective in the picture.

The photograph shows the austere strength of a landscape burnt by summer heat and drought. In the painting, the artist increased the tonal contrast, but wisely held back on the colour, using a relatively limited, bright but harmonious scheme to create an impressive image.

LIGHT AND COLOUR

One of the first and most imaginative descriptions of photography was 'The pencil of nature'. It was the title of a publication by one of the inventors of photography, William Fox Talbot, and the phrase referred to the fine beam of light that drew a picture onto the photographic plate.

Light is the essence of photography. If the sun is in the right position, the landscape will be illuminated and alive in the photo. If the weather or the time of day is wrong, the pictures will be flat and dull. The photographer can compensate, and improve a print to a certain extent in the darkroom, but the painter can transform the pictures, spreading a revealing pattern of light and shadow across the most unpromising subject.

Most painters working on site may add a few highlights or darken shadows to improve the overall effect of their work. Working from photographs extends this practice and enables the artist to restore or change the quality of light. There are three key factors in interpreting the light in an image: its direction, intensity and colour.

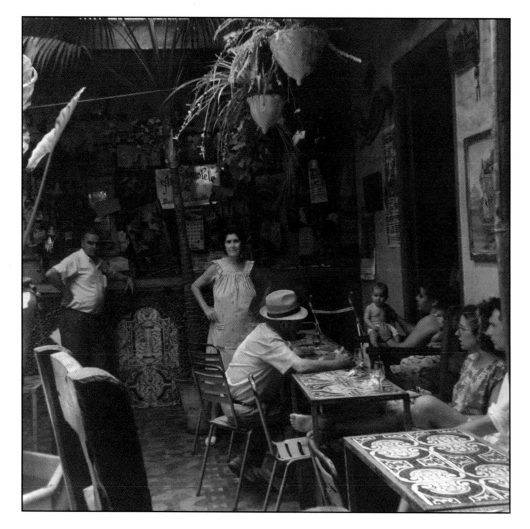

◀ Source photograph for *Cafe Interior* by Alison Dunhill. The quality of the colour print somewhat reduces the contrast of light and shadow, but the highlights clearly show that the light is entering the picture from the left.

Cafe Interior
oil
1530 x 1050 mm
(54 x 42 in)
The artist has adjusted the
balance of light and dark
tone, using the opaque
quality of the oil medium
to heighten tonal and
colour contrasts; for
example, the light striking
the back of the chair and
the highlighting of the
woman's face and arm.
The shapes and colours
are simplified to give the
painted image a strong
graphic feel.

DIRECTION

The direction of the light is an important
factor in creating a sense of both space and
weight in a painting. Nothing appears solid
without its shadow, and the presence of
highlights gives a painting 'life', or at least the
illusion of sunlight which we equate with

vitality. If a painting looks 'dead', you can be
pretty sure the painter has neglected to
consider the light on the subject or failed to
render it effectively.

The first step is deciding where the light
is coming from. If the light is clearly shown in
the photograph, painting it will be quite

► Source photograph for *The Roman Library in the Agora at Side, Turkey* by John Crossland. The black-and-white picture gives a strong impression of the hard Mediterranean light, which enters from top left and casts angled shadows on the ruins.

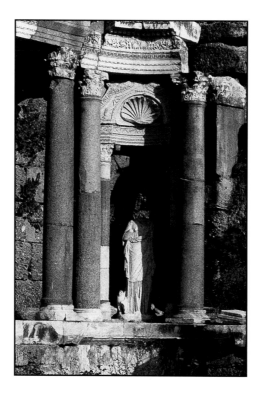

straightforward. However, many photographs have a rather ambiguous quality of light. In order to improve it, we must first examine the photograph in detail to find the direction of the light, no matter how feeble it may be.

Look for the shadows first; they are easier to see. Once you have located a shadow, the direction of the light can be deduced. A cast shadow falls away from the object creating it in the opposite direction from the location of the source of light. Indicate this direction by placing a small arrow on the edge of the paper or canvas you will be working on. As you paint, you can easily refer to this point for the direction of shadows and highlights. It is helpful to make a simple pencil sketch to begin with. You can use cross-hatching to indicate the shadows. In this way you can visualize the effect before committing yourself.

► JOHN
CROSSLAND

The Roman Library in the Agora at Side, Turkey
watercolour
355 x 255 mm
(14 x 10 in)
The original photograph, a holiday snapshot, was supplemented by book references illustrating this ancient site. This enabled the artist to extend the overall view of the composition, giving scope to intensify the qualities of light and shade across the middle ground and foreground.

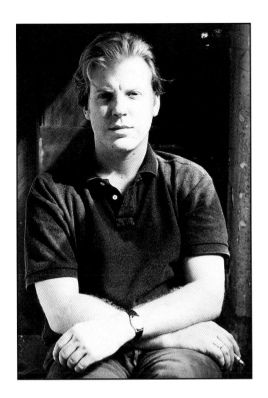

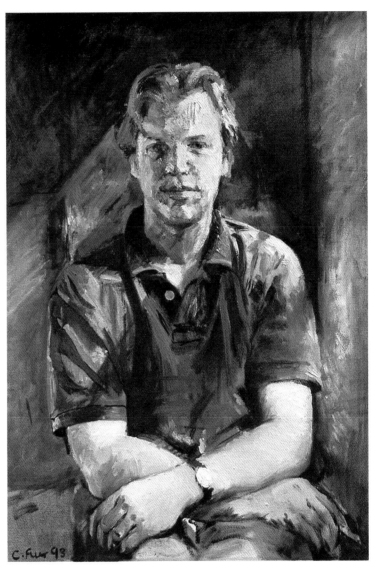

◀ Source photograph for *Mr Steven Cope* by Christian Furr. The negative was reversed during processing, so we see the subject as he would see himself in a mirror. Strong light from the side is often recommended for portraiture, as it enhances the modelling of face and figure and gives powerful accents of light and shade.

INTENSITY

The intensity of outdoor light varies according to the weather, time of day and geographical location. A painter can change the light of a northern landscape into a Mediterranean atmosphere by inserting deep shadows and bleached-out highlights. Tonal contrast is of paramount importance here (see pages 72–3); the greater the contrast in tones between light and shadow, the stronger the indication of sunlight.

Indoors, the intensity of light also varies in relation to its source and its closeness to the subject. If you are painting a portrait, still life or interior scene under an ordinary overhead light, the light is relatively diffused and the shadow pattern unremarkable. Positioning your subject in relation to an angled lamp or sunlight streaming through a window creates much more dramatic impact. If you take photographs as reference for paintings in an indoor situation, you can more easily control both the direction and the intensity of the light in the image, and its effect on the forms, colours and textures in your subject.

▲ **CHRISTIAN FURR**

Mr Steven Cope
oil on canvas
870 x 710 mm
(34¹/₄ x 28 in)
The artist has retained the diagonal direction of the light and its overall pattern, but strengthened the tonal contrasts to give the picture more depth. Certain confusing elements were eliminated, such as the glancing highlight on the cheek in the original photograph.

BACKLIGHTING

One of the basic tenets of photography is to take the picture with the light behind you so that the subject you are facing is illuminated (in fact, photographers obviously use light in much more complex ways to enliven their pictures, as many examples in this book show). I enjoy breaking rules, and I loved taking this shot with the source of light almost directly facing the camera, silhouetting the rhythmic shapes of the pines against the bright Mediterranean sky. An unusual photograph is often a good start for an interesting painting.

Painting on a coloured background is equally a challenge to find a completely new approach to a subject. I chose the bright blue paper because it is a very strong and difficult colour to work with, and I wanted to see where it might lead. It acts as a mid-tone for pastel work in the same way as a

◀ The original source photograph was a transparency; I made an enlarged colour laser print to work from.

neutral-coloured ground, on which the balance of light and dark tone must be found, but it also contributes a dynamic colour impact that helps to enhance the impression of dazzling light.

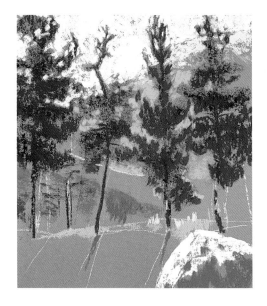

▶ **STEP 2**
With the trees broadly in place, the next obvious element was the light in the sky. I decided to put pure white over the blue paper for a dazzling effect, then softened the tone on the hillside behind the trees with the light green that suggests a sun-bleached landscape.

▲ **STEP 1**
As my main interest was the shapes of the trees against the sky, I first stroked in their rough silhouettes with dark-toned colours. I wanted the trees to 'dance'. The white rock in the foreground set the opposite extreme of the tonal range, as well as creating depth. It was also important to establish the ridge of warm light behind the base of the trees.

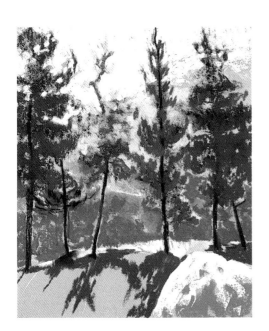

◀ STEP 3

As the work progressed I began to build up a range of colour variations, offsetting yellow-green against blue and blue-green, for example. Cast shadows in the foreground emphasize the lie of the land. With the heavier pastel work, the colours began to blend, but I retained glimpses of the blue paper showing through the overlaid strokes. This enhanced the feeling of movement.

PROJECT

● **Choose a photograph with a dramatic contrast of light and shade that simplifies shapes and textures.**

● **Select a strong-coloured, mid-toned paper to work on – such as bright red, blue or green. Look for a colour that either represents or completely contrasts with the main colour of your subject.**

● **Make a pastel or gouache painting from the photograph using six colours only, selected to cover the range of two dark, two medium and two light tones. Create the shapes boldly, avoiding too much colour blending.**

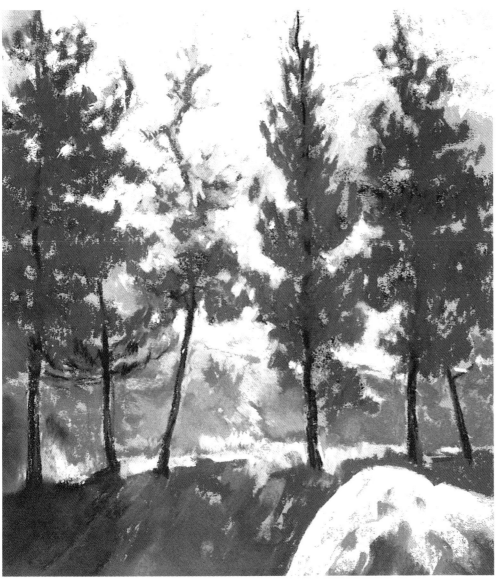

◀ DIANA CONSTANCE

Pines Against the Light
pastel
510 x 430 mm
(20 x 17 in)
I increased the range of dark tones in the foreground, softened parts of the background and heightened the highlights. The stronger contrast between the forest and the hills beyond finally reflects my true impression of looking out from deep shadow into the bright Mediterranean light.

► Source photograph for *New Forest Snow* by Jackie Simmonds. The wintry landscape is not actually snowy in the picture, but the colour and quality of the light suggested that possible interpretation.

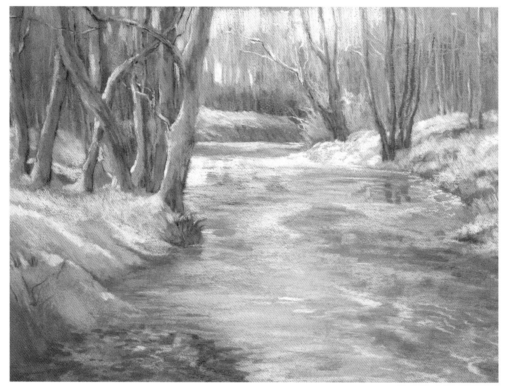

◄ **JACKIE SIMMONDS**
New Forest Snow
pastel
355 x 585 mm
(14 x 23 in)
The artist has taken a general balance of warm colour in the river and cool colour on the banks and in the trees and has made it more emphatic by the use of colours from opposite sides of the spectrum.

Warm yellow, pale orange and pink tints travel right through the centre of the picture, along the path of the river and up into the sky. The trees are all shaded with cool blues and blue-mauves. This direct contrast is carried through subtly in the pale tints creating the patches of sunlight falling through the trees. All the shadows are relatively light in tone, true darks being reserved for linear accenting.

COLOUR

The colour of the light is particularly affected by the time of day, and also responds to any pollution in the atmosphere. This is a neglected subject in many paintings, but it can enhance the mood and overall effect quite dramatically. The colour of light can be changed to intensify the mood of a painting or to soften it and bring it down to a lower key; in some pictures, the quality of light becomes the actual subject of the work.

When you are working in colour you are constantly making use of tonal contrast. But there is another element of contrast that has special impact on the colour of light in paintings. This is the variation through the colour spectrum of what are called 'warm' and 'cool' colours. Broadly, warm colours are golden yellows, oranges, reds, pinks, red-purples and red-browns; cool colours are blues and greens, blue-mauves, greenish-browns and the paler or more acid yellows, such as lemon yellow. Neutral colours such

▲ Source photograph for *Grand Canyon* by Pat Mallinson. The warm/cool contrast is apparent, but the picture was slightly bleached out by the heat-haze. Obviously a dramatic aerial shot like this was a one-off opportunity for the artist as tourist, and she had no time to gather other reference for the painting. In such a situation it is wise to bracket your exposures.

as grey and beige can also have a warm or cool bias, depending on whether there is a bluish or reddish tinge to them, for example.

Warm colours are active, glowing and enveloping; cool colours tend to be passive and imply distance, they are said to recede. This form of contrast can act in direct relation to tonal values, or in counterpoint, but it also helps to define the form and space in a composition. For example, a shadow need not be very dark; if it is very cool and set against a warm 'sunlit' colour it will have a similar effect to that created by a dark tone.

This is a relatively simple explanation of warm/cool contrast, because there are far more subtleties within the artist's palette and the way it is used. For example, a bluish-red such as alizarin crimson appears cooler than a hot, flame red such as vermilion. Likewise, viridian is a rich, deep green that can appear 'warmer' than an acid yellow-green. Bright cobalt blue may appear to recede when spread across a sky over a low horizon, but a patch of the same blue on a woman's dress can jump out from a portrait.

In general, however, the employment of warm and cool colours is a device that artists often use to enliven the depth and form of a picture. The principle may even be put into practice instinctively rather than deliberately. If you are not fully confident about using colour, it is easiest to divide the warm and cool colours in your palette quite simply to begin with, then explore the more complex effects as you progress.

▲ **PAT MALLINSON**
Grand Canyon
oil
1015 x 760 mm
(40 x 30 in)
The colours in the painting are strengthened and clarified to create a more powerful rendering of form and light. The pattern of light and shade is more dynamic for the artist's decision to extend the picture foreground and background, giving vertical stress that complements the high viewpoint.

CREATING INTENSE SUNLIGHT

The objective of this work was to give the impression of burning sunlight that would be appropriate to midsummer heat on the Greek island of Corfu. From the photograph, the light appeared to be coming from the left and slightly behind the house. This creates a highlighted plane down the left-hand side of the building, contrasting with the shadowing of the wall directly facing the viewer.

As the pastel painting progressed, these elements became gradually more intense. The artist began by placing dark-toned colour on the neutral ground to the left, creating the heavy, dark foliage mass that directly contrasted with the patch of white sunlight on the house front. These elements located the overall range of the tonal key. She then applied the mid-tones, gradually adding the appropriate colour areas. In the final stages, she reworked the degree of contrast, deepening the dark shadows in the buildings and trees and making sure the white highlights supplied clear, intense light.

▲ Source photograph for *A House on Corfu* by Freda Cowell. The impression of strong light is there, but the contrasts appear low key.

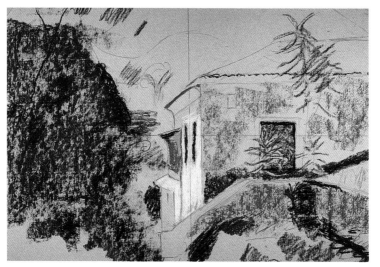

▲ STEP 1
The basic outlines of the scene were lightly sketched in pastel. The range of dark, medium and light tones was keyed with lightweight strokes, using the tips and sides of the pastel sticks.

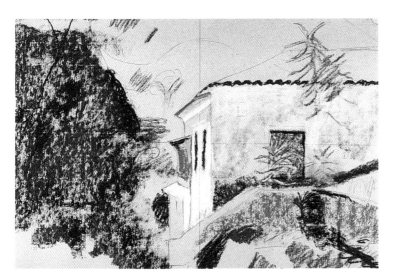

◀ STEP 2
To interpret the shadows in mid-tone, the artist chose to apply cool mauves and blue-purples (see page 81). The overall impression of the view had begun to emerge, though the elements of the scene were not yet really cohesive.

PROJECT

● **Make two drawings of a photograph of a house.**

● **Put small arrows at the top of each picture showing where the light is coming from.**

● **Paint the first drawing with very strong, dark shadows, using the same dark tone throughout wherever there is shade. Paint the highlights in the picture as light as possible.**

● **For the second painting, use a low contrast of tones between the shadow areas and highlights. Try using warm/cool colour contrasts instead, to model depth and form.**

◀ STEP 3
Working all over the drawing, the artist intensified the tonal contrasts. The sunlight was created by deepening the shadows and giving the architectural forms harder edges to emphasize this contrast. The addition of yellow-greens in the foliage also helped to light the painting.

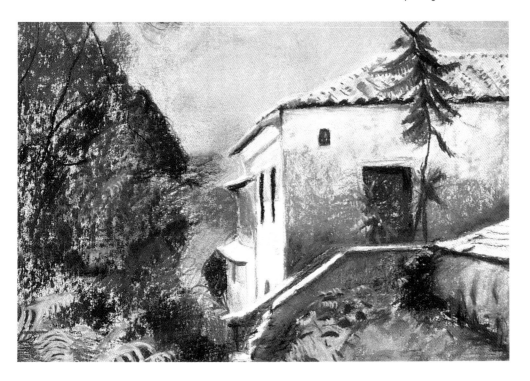

◀ FREDA COWELL
A House on Corfu
pastel
255 x 355 mm
(10 x 14 in)
Sharper definition of the foliage shapes in the foreground and middle ground added sparkle to the light effect, playing into the hard, geometric shapes of the buildings. The thin sweep of yellow pastel applied over the buff ground behind the house gave the impression of sunlight in the sky, though the actual colour of the sky was a hazy blue.

CHANGING THE LIGHT

The sun is the source of all light in an outdoor view, so one of the simplest and most effective ways to reinvent the mood of the painting is by changing the background light in the sky. In doing so, you have to alter all of the important elements that define it – its direction, intensity and colour. In turn, changes to these elements affect the other features of your painting: the colours of the landscape, for example, the position of highlights and shadows, and the degrees of tonal contrast. When you make a significant change, you also need to carry this through consistently in other parts of the work.

In his watercolour paintings shown on these pages, Martin Caulkin uses another highly effective visual resource for enhancing the colour and light in his subjects. He inserts watery pools and rutted tracks in the foreground of the pictures, which reflect the light of the sky all the more intensely. Like an alchemist, he magically transforms relatively mundane photo-images into glowing, mystical landscapes by his use of light. As an experienced artist, he can draw on his visual

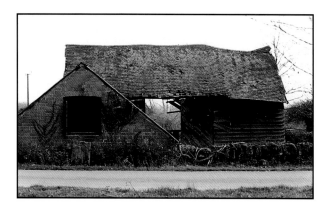

▲ Source photographs for *Fair Light* by Martin Caulkin. The artist passed this old barn frequently and began to take photos recording its decline.

▶ **MARTIN CAULKIN**
Fair Light
watercolour
295 x 380 mm
(11½ x 15 in)
Without the more dramatic light, this subject would not come alive. The artist used an extended foreground frame to add dignity to the venerable barn, and arranged the invented pools of water to lead us towards it.

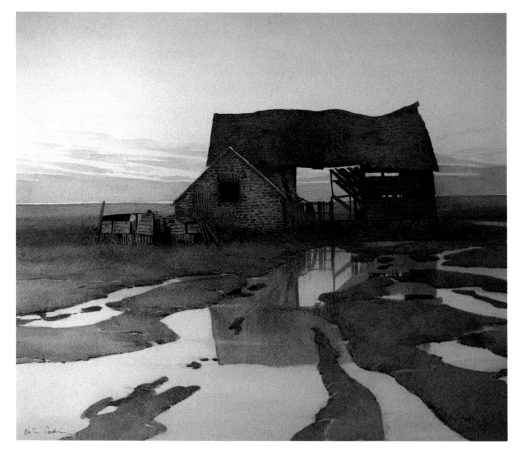

▶ Source photograph for *Winter Solstice* by Martin Caulkin. The small group of trees creates attractive shape and texture, but the image is flattened by the level ground and even light conditions.

▶ **MARTIN CAULKIN**

Winter Solstice
watercolour
180 x 280 mm
(7 x 11 in)
Reflections of evening light in the watery rutted tracks have become the centre of interest. The deep colour of the earth throws out the light in the water, which is intensely highlighted. This effect uses direct light-dark contrast and the play of warm/cool colour. Washes of blue and crimson evoke a mood and fix the time of day to an evening at solstice. The trees, unremarkable in the original photograph, have become mere background players, their shapes slightly altered and made translucent against the pervasive light.

memory and expert technique to add this kind of detailed impact to the work. But the less experienced painter can adapt the principle, using montaged photographs or photocopies (see pages 44–7) to combine individual elements of different images into a new and startling picture.

Using the particular qualities of your painting medium is an important aspect of achieving beautiful light effects. Martin Caulkin's technique is to draw the image, then wash in the palest tones using barely more than 'tinted water'. When the first washes have dried, he lays in additional layers, gradually building up the colour strength and tonal range. He allows the watercolour washes to remain loose.

The surface qualities of an oil, acrylic, gouache or pastel painting would be less delicate and atmospheric, because these are all opaque media. Rather than having the light shine through from the white paper beneath the paint, you would have to work the highlighting positively. The distribution of tones is the key element; notice that in both of these pictures, the water retains the highest tonal values, its shiny surface intensifying the reflected light from the sky.

MOOD AND EXPRESSION

Light is frequently the key element in a painting, never more so than in this triptych by Clifford Bayly, showing the stone alignments at Carnac at different times of day and under changing moods. Just a few photographs formed the basis for this ambitious composition, and the quality of the light enveloping the stones was critical to its success. It is a specially apt interpretation of the subject, as the stones at Carnac are generally believed to be associated with changes in the position of the sun, moon and stars. There are over 1000 stones that stretch over a distance of more than 1 kilometre (1000 yards).

The painter's imagination was well served by his organizational skills. He had to combine images of the overall alignment of the stones with the individual details that created focus and rhythm. He used a consistent framework for the light effect – notice the slanting angle of cast shadows from the stones throughout, which helps to unify the three sections – but cleverly varied the colour and quality of light as if from dawn to dusk, moving left to right across the three panels.

▶ This photo held the key shape of the twisted stone that would become the strong centre of interest needed for a triptych painting.

▲ These pictures show the overall alignment of the stones, which provided the foundation of the composition.

▲ The artist photographed the stones at dawn; the low sun created the golden light and long slanting shadows that tie the sections of the triptych together.

▲ The textural details of stones and grasses were taken from these pictures.

▼ **CLIFFORD BAYLY**
The Alignments
oil
1220 x 3290 mm
(48 x 130 in)
The landscape in the painting has been simplified to some extent. The overall mood of the work depends upon the warm light of the rising sun pushing the long shadows right through the changing colours of the image, presaging the passage of time as the full moon rises high in the last panel of the triptych. The depth of the picture comes mainly from the use of perspective in the arrangement of the stones, and also from the contrast of highly detailed forms and pattern in the foreground giving way to more generalized shapes and textures as the stones recede into the distance.

▲ This image gave the bluish light of evening and its close-toned effect on the forms of the stones.

DRAMATIC SKIES

▶ Source photograph of the sky, which shows the low light breaking intermittently through the slanting clouds.

The sky is a critical element in all outdoor subjects, and all good landscape painters will make the most of it, whatever its extent and contribution to the painting.

A sky can be painted as a simple backcloth of colour and light, or the setting of the drama of landscape, or the actual subject of the picture, even where the land is shown below. One of the great advantages of photography is the ability to freeze and hold an image for later analysis, and there are few subjects as elusive to paint as the fleeting forms of clouds and the infinitely changing colours of daylight.

If you have chosen an image for the dramatic qualities of its sky, you can decide to push this to the limit. Colours and shapes do not have to be strictly realistic; in fact, if you look at sky-dominated landscape pictures, you will often find a great deal of painterly invention in the way the colours and textures work. In this demonstration, I have worked from a transparency of a subtly colour-gradated evening sky with dynamically travelling cloud shapes, and I have used the direct, strong hues and tones of soft pastels to create a much more highly coloured expressive mood.

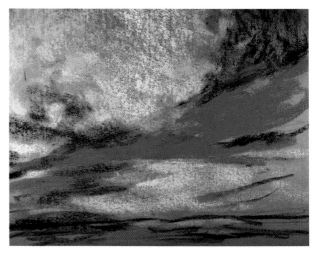

▲ **STEP 1**
I sketched the outlines of the cloud shapes roughly in charcoal on buff paper and laid in the strongest lights with white and yellow. I decided to extend and intensify the area of light above the central cloud. Skyscapes like this can provide basic stages for abstract paintings.

▲ **STEP 2**
As the contrast would be the key to making the image work, I coloured the cloud and background sky equally strongly, in opposite tones and colours.

▶ **STEP 3**
Continuing to build up the colours, the pastel textures began to blend and mesh, gradually pulling the elements of the composition together.

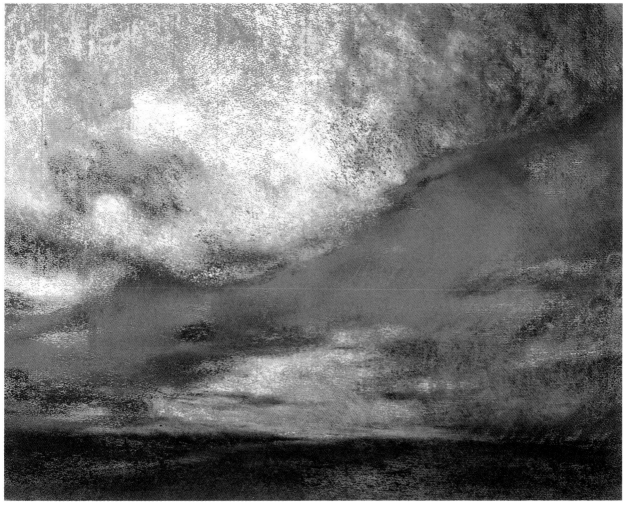

▲ **DIANA CONSTANCE**
Evening Sky
pastel
305 x 355 mm
(12 x 14 in)

In the final stage, I used white, red and black pastels to emphasize the light/dark variations and firm up the shapes. The paper surface contributed the grainy texture, breaking through the pastel strokes atmospherically, except where I built up the colour most heavily.

SPACE AND PERSPECTIVE

Artists have known for centuries that drawing a reflected image in a mirror is easier than turning round and drawing the subject directly. The image in the mirror (or in the photograph) is of course two-dimensional, ready-made. For the flat canvas or paper, it can be more easily copied than three-dimensional reality.

When working from photographs there is, however, a hidden problem which should be addressed. The photograph has great authority by nature of its seeming reality. One may forget the inherent flattening effect of its two-dimensional character. Without an awareness of the lost dimension of depth in the photograph, any painting that you make from it may look flat and will therefore be unconvincing. Fortunately, there are simple techniques that can be used to correct this flattening effect and create the illusion of space on the canvas.

DEFINING THE PICTURE SPACE

First, you should make a simple freehand sketch of the photograph – just draw the basic shapes. Start with the foreground, then the shapes in the middle ground, and finally the background. This instruction is a very generalized simplification which has to be modified to the specific image you are working with. But the principle of placing the elements of the composition into the illusory three-dimensional space of the

▶ Quick snapshot source for *Bali* by Estelle Spottiswoode. A diffuse, hazy light meant the sharp contrasts of tone between the mountain and lush jungle vegetation were lost; as a result the photograph contains too many mid-tones.

▶ **ESTELLE SPOTTISWOODE**
Bali
pastel
510 x 710 mm
(20 x 28 in)
The artist used her knowledge of tone and colour to restore the image she remembered, and used movement in the form of the mountain to strengthen the composition. The pinks and mauves in the shadows were clarified, but kept pale, creating an attractive contrast against the deep greens of the exotic jungle foliage.

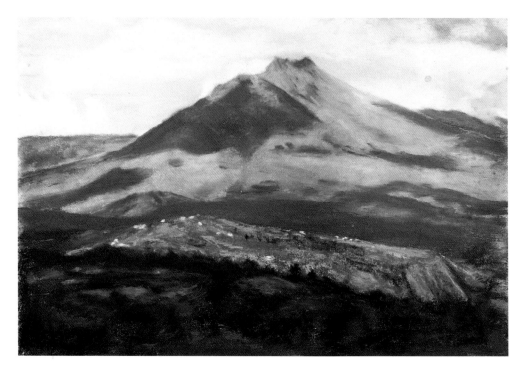

paper or canvas remains the same, whether you are working from a portrait photographed in a small room or a panoramic landscape.

You may find that most of the objects in your picture are in the middle distance. In this case, the composition can be strengthened by moving one part forwards or backwards to create more pictorial space between. If this is not possible, then something from another photograph or sketchbook reference can be added to the foreground of the painting.

When a landscape photograph appears flat, it is often the quality of the light that is at fault. Changing the tones of the photograph for a stronger contrast between the objects near to you and those in the background increases the illusion of depth in the picture plane. The tones in the background should be kept lighter so that the image appears to fade away gently. In a landscape, a pale blue or mauve can be used with some of the background colours. Traditionally, distant hills or other objects near the horizon are painted with these cool colours to push them back into infinity, and the detail is indistinct. Warmer colours and stronger textural marks bring other areas forward.

Some photographers try to minimize shadows in their work. The best ones, however, know that shadows can be one of the most effective ways of emphasizing the natural space in a picture. Frequently, artists add shadows to a painting that may not be in the photograph at all. Cast shadows define the physical reality of an object in space, and can be used to lead the eye into the picture or to extend the space of the composition. The basic material in a photograph can be manipulated to create an immense sense of depth.

▼ **ALISON DUNHILL**
Field of Daffodils
oil pastel
255 x 205 mm
(10 x 8 in)
Here the cast shadows are the centre of interest rather than the daffodils themselves. The colours and tones are strong and highly contrasted, filling the landscape with vitality. The use of perspective, with the converging lines leading through the centre of the picture, gives a sense of space and depth well suited to the subject. A camera was essential to capture this acute angle.

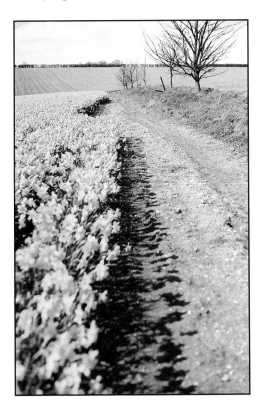

▲ Source photograph for *Field of Daffodils* by Alison Dunhill. The camera was used on its side and the field was photographed from a low angle.

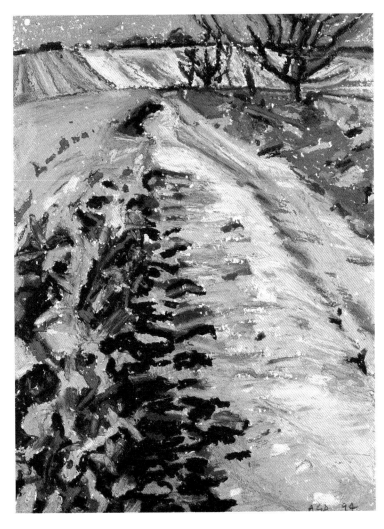

UNUSUAL VIEWPOINTS

Strong angles of perspective can create a sense of space and depth. This is something to consider when you take the original photograph. One of the advantages of using a camera is the ability it gives you to take your 'visual notes' from odd or difficult angles. Use the viewfinder of your camera as a frame and look at the potential subject from both high and low angles, as well as a normal eye level.

Space is a potent tool for creating a mood of isolation or claustrophobia. For example, if a person is photographed from a distance in a landscape or in a large room, they appear isolated solely by virtue of the space around them, and regardless of their facial expression. If the camera is moved into tight close-up, the mood changes, creating a composition with a radical edge as the viewer is pushed 'on top' of the subject. This technique is sometimes used for portraiture: the invasion of the space around the person sometimes produces an unusual and disturbing image.

A similar device was used to isolate an object in Martin Caulkin's watercolour painting of *Mike's Scammell* (right). In this case, the artist invented a new perspective of the truck that was not in his reference photos, a change which requires some technical knowledge of how perspective works. But the mood of the picture is created mainly by the isolation of the truck in a vastly extended space.

The best advice is to experiment by taking several different photographs of the same subject from different eye levels and viewpoints, both close up and further back from the subject. This use of perspective should introduce some new ideas into your compositions. Using a wide-angle lens (28mm or 35mm) also changes the perspective of the photograph.

▼ Source photograph for *Ruined Cottage* by Donald Cordery. The artist was fascinated by the abstract qualities and shapes of this enclosed view and the rich combination of colour and light.

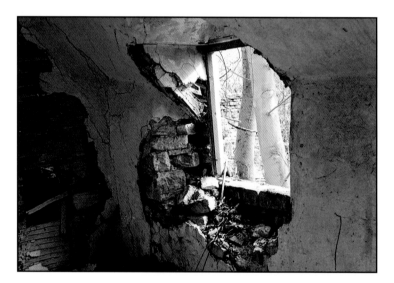

▶ **DONALD CORDERY**
Ruined Cottage
watercolour
225 x 280 mm
(9 x 11 in)
The painting is quite faithful to the source photograph, but the artist has enriched the contrasts of colour and tone, which gives a more distinctive impression of the tight space within the old ruined building as well as a cleaner focus on the dramatic break into dazzling outdoor light through the angled window.

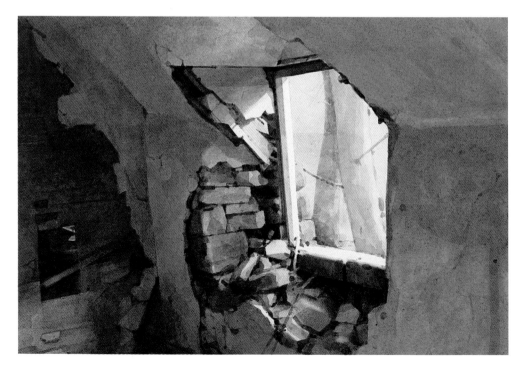

► Source photograph for *Mike's Scammell* by Martin Caulkin. This was taken at normal eye level, with the truck standing stationary in the farmyard.

▲ **MARTIN CAULKIN**
Mike's Scammell
watercolour
560 x 760 mm
(22 x 30 in)

By placing the vehicle in isolation on the brow of a hill, the image was transformed. The perspective of the truck was tilted back to silhouette the heavy mechanical shape against the background of the sky. The deep tones in the painting add to the dark mood, in which this formerly unremarkable object seems to have become a menacing beast that gazes at us with sightless eyes.

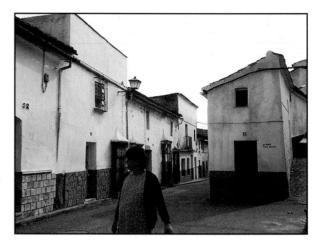

▲ Source photographs for *Vejer de la Frontera* by Pat Mallinson. The relationship of the two viewpoints is clear, keyed in by the compact shape of the corner house positioned at the centre of the first picture and moved to the right in the second picture.

▶ **PAT MALLINSON**
Vejer de la Frontera
pastel
560 x 760 mm
(22 x 30 in)
The dark shape of the woman in the foreground placed along the line of light, leads our eyes into the full depth of the picture through the extended angle and length of the main street to the right. The slanting roofs of the buildings on the left contain the composition and direct the eye back to the centre. The contrast of tones has heightened the pictorial tension and counterpoints the restrained use of colour appropriate to the subject.

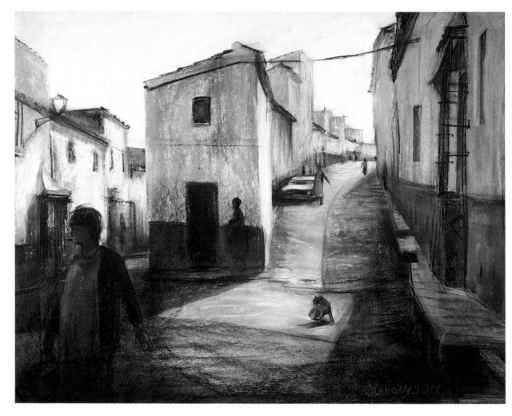

ANGLES OF PERSPECTIVE

Emphasizing angles of perspective and extending the lines of some elements in a painting are other methods of increasing the spatial qualities of the composition. Obviously certain photographs lend themselves more to such changes than others. Roads, walls, architecture and cast shadows can all be useful aids to leading the eye into the picture. For her painting of the small Spanish village *Vejer de la Frontera* (above), Pat Mallinson photographed the street from two different angles and then fitted the photographs together, to be able to extend the angle and length of the road for dramatic effect.

Clifford Bayly's photograph of old Rabat in Malta, taken from a high viewpoint, spreads out the town before our eyes and reveals a complex pattern of interlocking shapes. In his watercolour painting (right), the artist chose to draw us into the view more closely by cropping some of the townscape. He selected a part of it as the focus of his painting, which had the effect of raising the horizon line and squaring the

more broadly horizontal format of the original picture plane.

If you are not experienced with drawing architecture, a confusing mass of it, such as in the Rabat picture, can be enlarged in a photocopier. The photocopy can be cropped and worked on until you are satisfied with it. Then it can be transferred to your paper. You can enhance the space and depth in the final composition by careful use of colour and tone in association with the perspective drawing.

▶ Source photo for *Rabat, Malta* by Clifford Bayly, giving a broad panoramic view above the old town.

▼ **CLIFFORD BAYLY**
Rabat, Malta
watercolour
280 x 380 mm
(11 x 15 in)
The new, closer perspective has enabled the artist to create a beautifully formalized impression of the townscape, with a slight tilt compared to the original viewpoint, which emphasizes height. The harmonious colours have been cleverly ordered to clarify the complex perspective, using transparent watercolour washes that allow the line work to hold the spatial framework firmly.

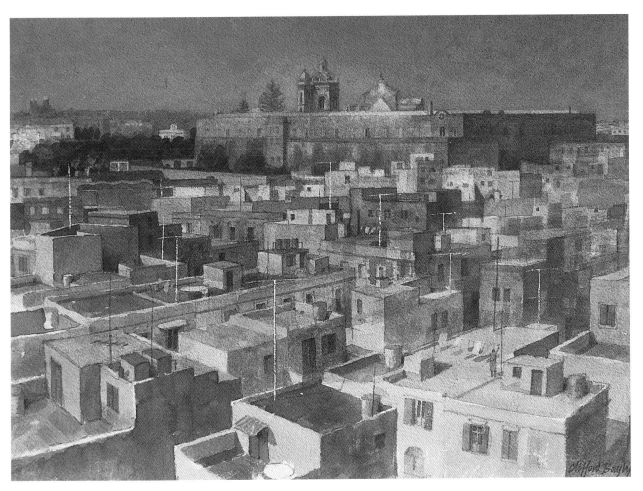

CORRECTING PERSPECTIVES

Snatched pictures frequently contain odd angles of perspective. Incorrect perspective is difficult to solve without a bit of help. The simplest method is to trace the subjects in the photograph and then turn the tracing into the correct angle or position against the clean background of a sheet of white paper. Once you have made any other corrections that are necessary, the traced image can be enlarged in a photocopier and transferred directly to your paper or canvas.

Using one part of a photograph with another is usually straightforward, but there are a few perspective problems to look out for. When you transfer an object into a background that you have taken from another photograph, you must be sure that

the object was photographed from the same eye level as the background you intend to add it to.

The other point to watch out for is scale of the object you put into the picture. Try measuring it against some details in the background, such as a house or tree.

▲ Source photographs for *Kittens on a Chair* by Gillian Carolan. Photographs of animals inevitably have to be taken quickly and can present you with some odd impressions of angle and perspective.

▶ Enlarged tracing on acetate. This was taken directly from the third photograph of the kittens.

▶ The traced image with a turned perspective, shown in black on this drawing. The corrected perspective is the rectangle marked in red. This is a reconstruction of how the artist could have tackled the perspective problem in this subject.

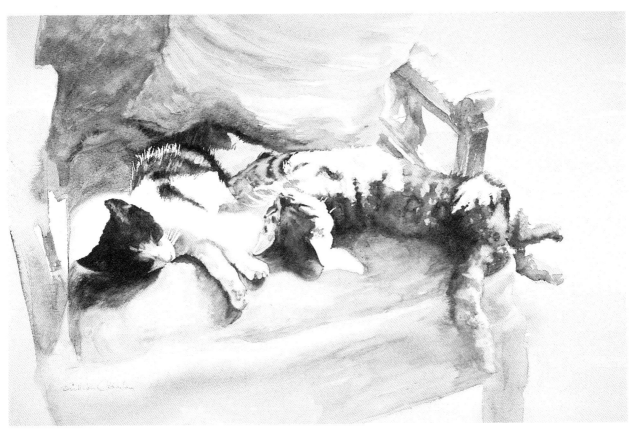

▲ GILLIAN CAROLAN

Kittens on a Chair
watercolour
305 x 455mm (12 x 18 in)

With her experience of drawing and composition, the artist was in fact able to arrive at a satisfactory composite painting of the kittens by drawing them freehand from the photographs. You may wish to use the tracing method to produce your image.

PERSPECTIVE AND MOOD

This panoramic painting of Florence by David Carr not only describes its subject with a strong sense of place, but establishes a mood for the cityscape by the quality of light and the atmospheric effect of the sky. The sources for the painting were an enlargement of part of a photograph, and a gouache study done on the spot by the artist showing the same view under a dramatic evening sky.

With a broad cityscape like this, it is vitally important to have a firm structure and centre of interest. By nature, this kind of image is over-complicated, with an abundance of detail. There are often too many small shapes similar in size and tone. The artist must come in with the determination to cut out a clear form from a mass of material.

David Carr has used a number of pictorial devices to clarify and enhance the impression of space and distance shown in the photograph. The photo is relatively dark and close-toned. This somewhat flattens the depth of the cityscape, confusng

◀ Source photograph for *Florence* by David Carr.

the individual shapes. A haze has caused the mountains behind to fade out abruptly, which also decreases the sense of distance in the view overall. Aided by the gouache study, which has a more emphatic tonal range and a lower perspective revealing more background, the artist has adjusted the viewpoint and scale of the larger composition. When painting, he worked in a brighter, broader tonal range to increase the perspective across the landscape and bring out the variety of form and detail in the architectural masses.

▶ **DAVID CARR**
View of Florence from the Belvedere
gouache
180 x 280 mm
(7 x 11 in)
The gouache study focused on the clouds rolling in as the evening sunlight caught the Brunelleschi dome of the Duomo and the rooftops of Florence. In this study, the foreground plane of the view is cut shorter than in the photograph.

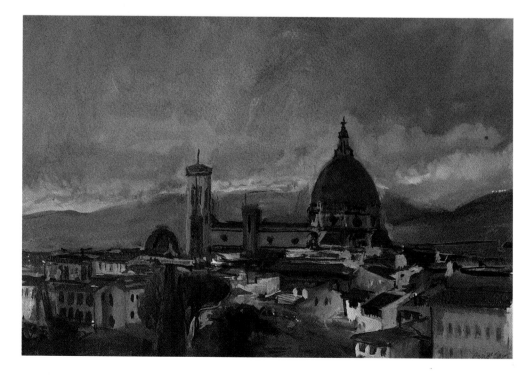

◀ **STEP 1**
The basic forms in the cityscape were established with charcoal drawing, combining the perspectives of the photograph and gouache study. The interaction of the moving clouds with the complex layout of the city spread out below was rapidly indicated in the first colour applications, using a large brush to create activity in the sky.

◀ **STEP 2**
The artist worked outwards across the composition, extending the colour work and revising the relationships of colours and tones. The contrast of flat and textured colour areas in the cityscape began to provide a clearer definition of individual forms. The artist used watercolour, gouache and acrylic paints to develop the textures.

▶ STEP 3

At the top of the picture the sky was lightened and pushed back for better contrast with the buildings. At the bottom, the foreground was darkened to contrast with and frame the centre of interest of this cityscape.

▶ STEP 4

By this stage, the artist was not only filling in the last unpainted areas, but continuously revising the relationships of tones and colours to enhance the light in the painting and deepen the space.

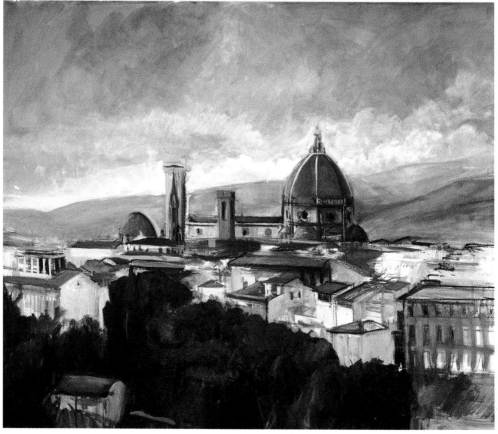

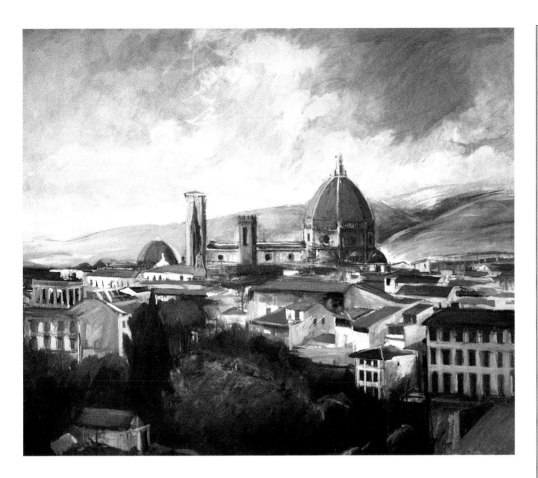

▲ DAVID CARR
Florence
mixed media
1220 x 1525 mm
(40 x 60 in)
The finished painting is a much more vital, atmospheric view of the city as compared to the photograph. The artist's feeling for detail and colour has brought back the immediacy of such an impressive view of the historic site.

The impression of space and depth in the picture plane is enhanced by the artist's close attention to the scale of the architectural features and trees. These 'marks' are carefully diminished in size so that they appear to recede naturally into the distance. They are indicated rather than painted with sharp precision. A small brush used with a light touch has helped to soften and fade back the shapes. Cooler tones of grey, mauve and blue give the illusion of the dense atmosphere and pollution that you see when you look straight across at the horizon instead of looking upwards.

PROJECT

● Use a whole roll of film to take pictures of a city or townscape. Move around as much as possible, and use the camera viewfinder to select interesting ways of framing your subject.

● Include some pictures from a high viewpoint, such as a wall or tower, and some from a low position, crouching or lying on the ground to take the shot.

● Vary the position of the horizon and turn the camera sideways for some of the photographs.

● Select a suitable photograph, or combination of photos, for a painting, and make freehand drawings to work out the composition.

● Paint the composition in watercolour, gouache or acrylic, using your range of colours and tones to enhance the space and depth you created in the drawing.

LANDSCAPE AND CITYSCAPE

There are very few landscape painters now who do not carry a camera with their sketching kit. Even purists will take a few reference snaps to help them later on. The degree to which photographs are used varies enormously.

One of the obvious advantages of photography in outdoor work is that it 'stops time' – the sunlight and shadows in a photograph do not move. The shapes and motions of fleeting clouds are caught and preserved. You have time to study the forms without wind or rain interfering.

Painting a landscape from photographs is not the same experience and not a replacement for painting on site, but it can make a valuable contribution and improve your landscape painting. Painting outdoors helps you to build up impressions of the landscape; the ideas that you form working directly from nature become a part of the mulch that can nurture the work you do

with photographs. But photography allows you to work at your own pace and in your own home, giving time and freedom to explore all the possibilities of your subject.

PHOTOGRAPHING LANDSCAPES

The time of day is the critical element in landscape work. The same scene presents different faces to us, depending on the weather and the hour. In the morning the air is clear; the direction of the sun illuminates parts of the landscape, adding long shadows

◄ Source photograph for *Summer Evening, Hackwood Park* by Donald Cordery. The light in the photograph, taken late in the day, is somewhat hazy and subdued.

◄ **DONALD CORDERY**
Summer Evening, Hackwood Park
watercolour
100 x 150 mm
(4 x 6 in)
In the painting, the artist has used a precise, dry-brushed stipple technique, which enables pure colours to be interwoven on the paper. This has helped to restore the warmth and vitality of the light and has given more colour to the dark shapes of the trees.

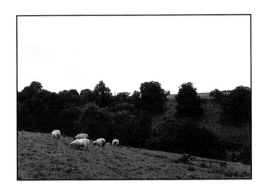

▲ Source photographs for *Approaching Storm* by Donald Cordery. The mood of the landscape is affected by the gathering storm in the sky. The artist took a separate photograph of the skyscape and combined the two images in the painting. The sky photo was deliberately under-exposed to obtain a dark, moody image.

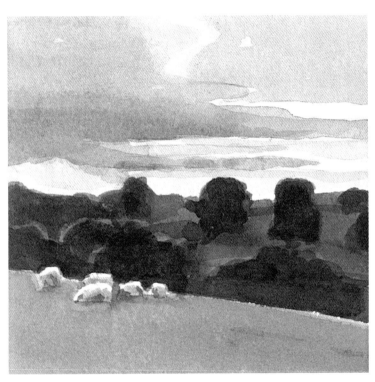

▲ **DONALD CORDERY**
Approaching Storm
watercolour
125 x 140 mm
(5 x 5½ in)
The artist's intention was to lay in the painting very simply and directly, avoiding the temptation to alter it. The more dramatic qualities of the sky from the second photograph give dynamism, and the shapes of the trees and sheep, though relatively abstract, remain highly descriptive.

and strong contrasts. The late afternoon is another good time, and the warm light of the setting sun gives another dimension to landscape. Cast shadows can be used as strong compositional elements giving depth and a sense of space to the photograph.

Remember to use your camera viewfinder as a frame for the composition, making the possible variations easier to see. Once you have decided on the main area of the picture, it is useful to make supporting photographs of some of the detail from which to work, in the same way that you would make quick jottings on a pad.

Bright sunlight with its accompanying deep shadow can cause bleaching out of one part of your picture while other areas, which are in shadow, can be completely lost by under-exposure. The answer to this is bracketing: take one correct exposure, one that is under-exposed and one over-exposed. With a camera with an automatic exposure meter, you can change the ASA rating to make the camera 'think' the film is more or less sensitive than it is. Just do not forget to readjust the setting when you have finished bracketing.

For poor lighting landscape photography, there are two ways to proceed. You can use a fast film of 400 or 1000 ASA, with the shutter speed of a manual camera adjusted to one-sixtieth of a second. With automatic cameras, the speed and exposure are adjusted for you, but make sure you set the correct ASA number if the camera does not 'read' it from the film.

This combination of fast film and short exposure time will allow you to hand-hold the camera in poor light. Its drawback is the coarse grain of the film. If you want to use a slower (finer-grained) film, then you must use a tripod to steady the camera during the longer exposures. If your camera can take a cable lead for the shutter release, it is advisable to minimize the movement involved in pressing the button. But for a painter, a bit of blurring or grain is not that important, as long as you can see enough of the picture for reference.

A BROAD VIEW OF LANDSCAPE

David Carr is from the North Riding of Yorkshire, and his painter's vision reflects its vast rolling moorlands. The dourness of the landscape, with its romantic and turbulent skies, has been the inspiration for some of Britain's finest landscape painters and writers. David follows this tradition and has a natural empathy for the panoramic view. He invests his paintings with feeling and mood beyond simple portrayal.

It would have been impossible to paint this vast scene of Whitby on site – it was even difficult to photograph. The artist wanted the composition to take in more of the bay, but from where he had to stand, the angle was impossible. He had to use two photographs to construct and elongate the view. He took them from the same height and angle, keeping a check on the edge of

the first picture and matching it to the next frame. The photos were pasted on board, fitting the two parts of the scene together, and the whole composition was extended into a painted montage.

If you want to create a large, open view of a landscape site or feature, try taking two or three sequential photographs like this. You can use a tripod or camera easel, holding the camera steady at one level and turning slightly on each take so that you shift across the subject evenly. Try to match the edge of one exposure to the next as you take the pictures, allowing a slight overlap, but any slight deficiencies can be corrected later when you join up the view.

▲ The original montage of *Whitby Harbour* by David Carr, made from two photographs overlapped on a cardboard background. The artist has worked on them with gouache and charcoal to unify the tones and fill out the composition. He has added the diagonal line of the clouds and light in the sky, which creates a stronger design against the cliffs than the empty sky in the photo. This image is in itself an excellent union of painting and photography.

▶ To define the area to be used for the painted composition, the artist framed the montage with two L-shaped pieces of paper.

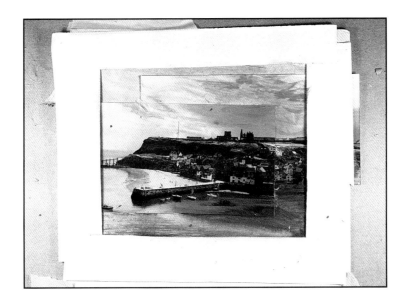

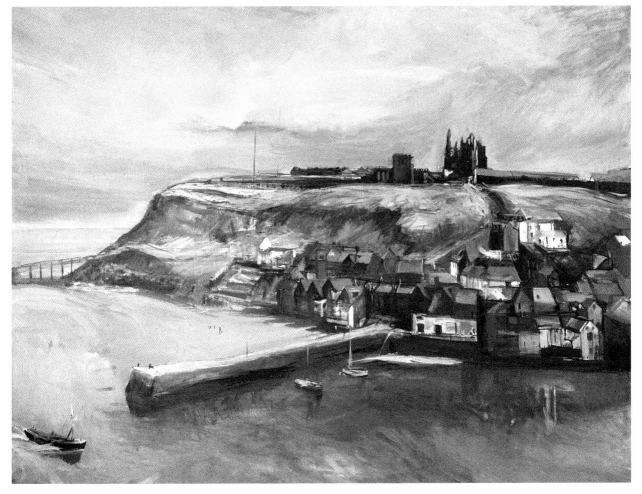

▲ DAVID CARR
Whitby Harbour
watercolour and gouache
1220 x 1525 mm
(48 x 60 in)

The finished painting has a greater dimension of light and space than the photographs. The combination of transparent watercolour and opaque gouache has created a powerful atmospheric range in the surface textures of the painting.

THE STRUCTURE OF CITYSCAPE

This painting has a panoramic feel to it in the same way as Carr's *Whitby Harbour*. However, the pattern of the cityscape creates distinct divisions in the picture plane: foreground, middle ground and distance. The focus is on the houses in the middle distance, with the foreground trees and road used as a frame. The skyline of modern buildings offsets the more characterful houses in front of them, and its geometric pattern contrasts with the natural shapes of the palm trees.

The artist made pencil, pastel and watercolour studies on site. He painted in the morning, before the heat of the day had started, but returned to take his reference photograph in the early evening; you can see how the light has changed.

▼ Source photograph for *San Francisco from Alamo Square* by David Carr. It was early evening and the sun was beginning to go down behind the artist when he took this picture. The trees stand out as dark forms over the still-illuminated cityscape, and serve as a backdrop to the scene.

◄ Pencil drawing of the view made on site. The artist has established in clear detail the perspective impression of the view and all the overlapping elements of structural and natural forms that interlock within the panorama.

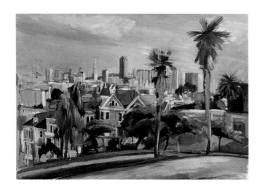

▲ Pastel and watercolour painting made early in the day on site. This shows a fairly cool, glancing light that picks out the tonal structure of the image.

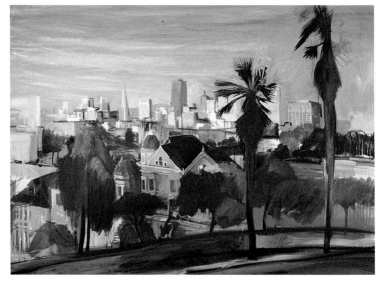

▲ **STEP 1**
The artist has begun by blocking in the picture loosely, giving precedence to the dark pattern of the trees and shadows, but he has already created the golden glow of the light that was in the evening photograph.

► **STEP 2**

The tones of the houses in the middle distance have been carefully modulated to show the light on the forms and the depth of one of the typical steep hills of San Francisco.

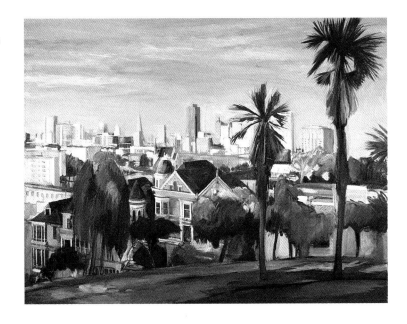

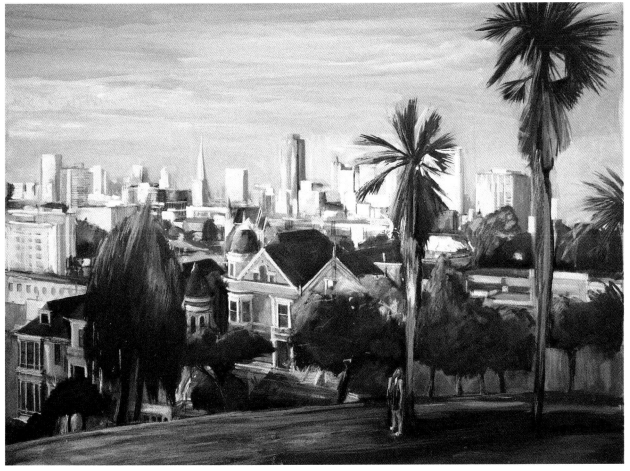

▲ **DAVID CARR**
San Francisco from Alamo Square
1220 x 1525 mm
(48 x 60 in)

The colour work has been intensified to create additional light and detail across the whole view. A figure has suddenly appeared in the foreground of the cityscape, who seems more of an onlooker than a part of it, thus giving the painting a poetic mood. Using mixed media, as in this painting, offers the artist a range of options.

A SENSE OF PLACE

Landscape painting does not have to concern just what we see, it can also be about the spirit of a place. Photographs give you time to draw out gradually what you cannot see on the surface. What started as a simple landscape picture can develop a narrative message. Parts of other photographs of your own can be added to the composition, or even found pictures from newspapers or magazines.

One of Clifford Bayly's particular interests is painting ancient sites in the landscape, where visual evidence remains of our ancestors' close relationship with their environment. He brings a strong sense of design and structure to his work, which has a deep commitment to environmental issues. He supports his concern with evocative paintings such as this one of Lindisfarne, or Holy Island, the first bastion of Christianity in northern England. The sea wall shown in the painting is known as Stag Rock. An unknown person painted the stag many years ago, and mysteriously returns every year to repair it.

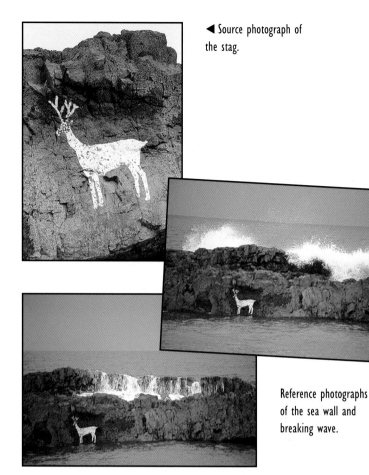

◄ Source photograph of the stag.

Reference photographs of the sea wall and breaking wave.

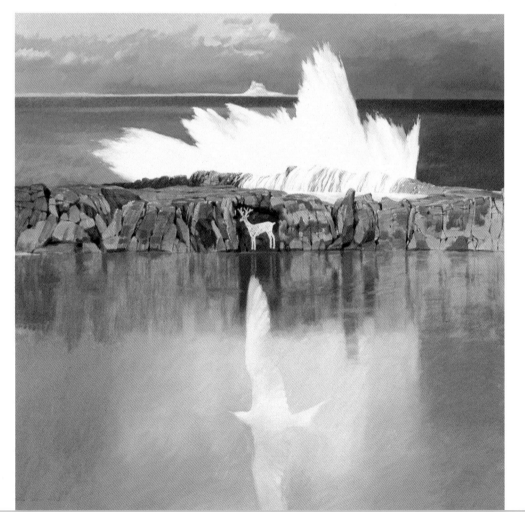

◄ CLIFFORD BAYLY
Lindisfarne from Bamburgh
acrylic
1220 x 1220 mm
(48 x 48 in)
The squarer format of the canvas gives the artist a longer perspective view than in the photographs. He has used the space to create a calm effect of shimmering light in the foreground that contrasts with the bright, graphic splash of the wave breaking up behind the stag. The qualities of acrylic paint enabled the artist to build strong contrasts of tone and crisply defined shapes.

◀ Source photograph for *Water over Rocks — Great Langdale, Cumbria* by Donald Cordery.

Water is a specially evocative landscape feature, and its textures and movement can be fascinating, though often difficult, to paint. Donald Cordery's painting of a fall of water over rocks at Great Langdale in Cumbria was an attempt to portray the abstract qualities of the detailed, close view, while retaining a broader sense of place.

▲ **DONALD CORDERY**

Water over Rocks — Great Langdale, Cumbria
305 x 355 mm
(12 x 14 in)

In this watercolour painting the artist has chosen an austerely limited palette and modulated the tonal range carefully between very dark and very light. The movement of the water, its translucency below the rocks, and the apparent solidity of the tumbling foam are brilliantly captured by the range of brush marks and variations in the depth of the watercolour layers.

DEVELOPING A LANDSCAPE COMPOSITION

The picture sequences on these pages give us rare insight into the preparation and development of a major work. The artist, Clifford Bayly, was commissioned by the Winchester Health Authority to produce a painting for the Accident and Emergency department of the Royal Hampshire County Hospital. He decided to use the format of a triptych, dividing the long space available for the painting into three panels, all of which would have their own centre of interest and individual composition, but would work together harmoniously over the 2.75m (9ft) expanse. Thus the painting could be seen as one imposing composition from a distance, or as separate works for a viewer walking close by.

The design of the work took a great deal of planning. Each panel centres on one of Winchester's major architectural features, against a background landscape encompassing the sweep of the Hampshire Downs. The artist had to assemble fragmentary information from many photographs to cover the different details needed for each panel, and it was not always possible to obtain exact, direct reference for individual elements. A sense of order in the painting's composition had to be created out of the apparent chaos of the varied photographic sources.

He began by using a common eye level and perspective for all of the buildings. For each panel, he had to select essential information from the photographs, adjust the perspective and move things around. The backgrounds were connected by the curving line of the downs, to carry the viewer across the three parts of the image and bind them together. The height of the downs was exaggerated to emphasize the 'hidden' aspect of the historic city.

For each of the panels, the artist used the technique of underpainting in acrylics before starting to work the texture and detail in oil paint. Acrylics dry quickly and give a matt base or 'key' on which to work up oil glazes or impasto.

▼ The artist saved what was useful in this photograph, the two trees on the left and those on the right, and dispensed with the remaining clutter.

► Reference photograph for the cathedral and background. This gives a sense of the overall setting and a clear shape to the cathedral as focal point. The trees that create the soft horizontal stress in the foreground of the painting were reorganized with the help of the second photograph.

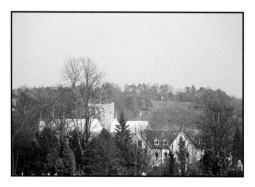

► The background reference shows the daffodil fields, which were heightened in both shape and colour for the final composition.

LEFT-HAND PANEL

The image of Winchester Cathedral shows the relatively stark lines of the building against a hazy, spreading townscape in the middle ground. The 'flow' of this area of the painting allows the eye to travel around the composition and be brought back into the centre, where the sunlit, pale tone of the cathedral stands out. The bright arc of colour created by daffodil fields on the distant hill provides a dramatic balance to the image.

This section of the triptych is shown here as a step-by-step sequence. In terms of technique and image development, it represents the progress of all three panels.

▶ **STEP 1**

The tonal basis for the painting was laid out to give simple definition to the main shapes, working from background to foreground. The acrylic paint was applied thinly with loose brushwork for a light, airy effect.

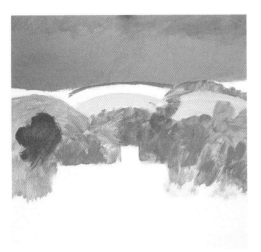

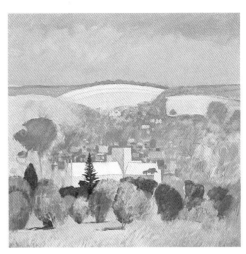

▲ **STEP 2**

The artist began working in oil over the acrylic underpainting, using different-sized brushes to begin to evaluate the scale and detail. The townscape was painted in the same range of tones as the hillside, to allow the shapes to merge into it and stay in the background, whereas the trees in the foreground have sharper contrasts of colour and tone to bring them forward.

▶ **LEFT-HAND PANEL**

A dramatic firming of the painting's space and structure has taken place in the final stages. Although the scale of the painting has forced the artist to simplify the detail, there are many small touches that give essential definition to buildings and trees. The tonal range of the image has been carefully modulated to develop the feeling of space.

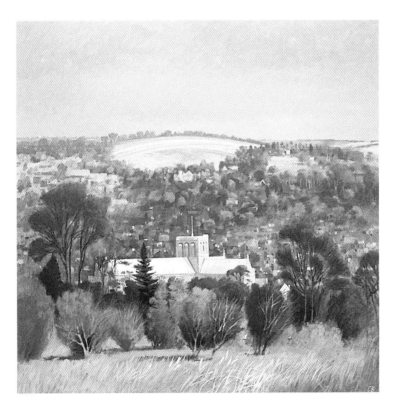

CENTRE PANEL

The focus of the centre panel is the imposing structure of the Winchester College Chapel, with its sunlit, tall tower lifting the eye upwards through the converging patterns of the hillside. The reference photograph for the building could not be taken straight on, and shows it at an awkward angle that had to be 'turned' for the frontal view in the painting. This was done by drawing the basic shape of the tower and the triangular section of the chapel roof in front of it, then transferring the details of the architecture in the correct perspective view. As in the left-hand panel, a middle ground of townscape behind the central building adds context and interest.

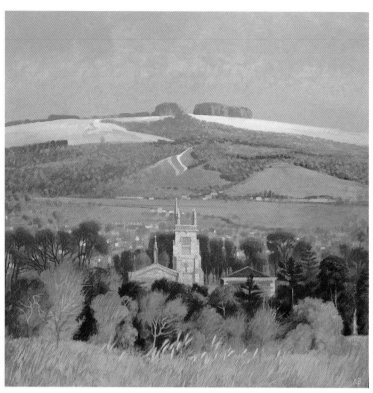

▲ Close-up reference photograph for the chapel building (top). The clear details of the architecture and stonework were reconstructed for the painting within a flat, face-on view of the tower, as if this image had rotated towards you from left to right.

▲ The background reference (above) shows a very gentle curve on the horizon, which was more sharply defined in the painting.

▲ **CENTRE PANEL**
This panel is the anchoring section of the triptych when it is seen as a single, cohesive work. The composition 'peaks' at the centre so the eye easily returns outward to the flanking panels. The background contains strong, dynamic subdivisions that could have overwhelmed the painting, but the foreground has been brought out with vigorous shapes and contrasts.

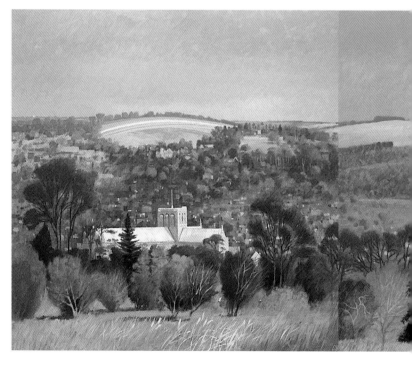

RIGHT-HAND PANEL

In the right-hand panel, the structure of the building and the hill rising behind both reflect the arrangement of the left-hand panel, completing the overall balance of the triptych. You can see how the artist has used his licence in each case to increase the height of the background landscape and slightly alter its shape, giving the composition depth and symmetry.

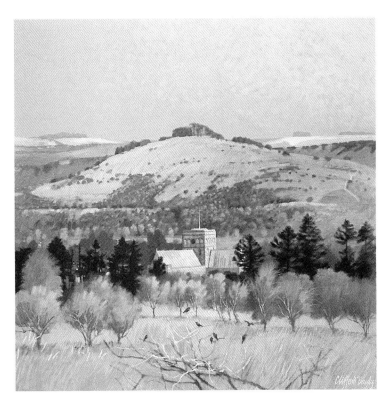

◀ Reference photograph for the St Cross Hospice building (left). The straight-on view was used directly, although the painting raises the artist's eye level as compared to this elevation. The curving form of St Catherine's Hill (above left) was moved in behind the Hospice and its height was greatly increased.

▲ **RIGHT-HAND PANEL**

The form and movement of this composition leads the eye in from the right down the line of trees, which is reinforced by the sharp, eye-catching angles of their crisply delineated trunks and branches.

◀ **CLIFFORD BAYLY**

Three Views of Winchester
acrylic and oil
915 x 2745 mm
(36 x 108 in)
The panels are beautifully linked in terms of content, shape and colour, and the artist has applied a consistent direction of light. Precise but lively brushwork in the details retained the freshness of the original concept, creating a painting to lift the spirits.

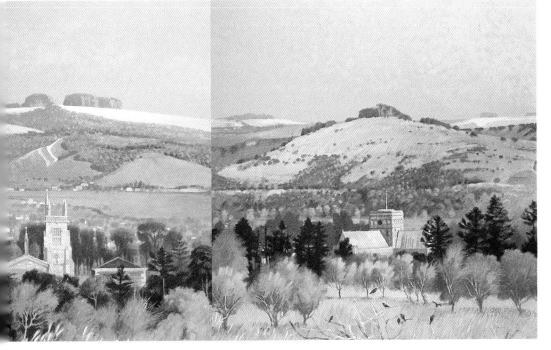

PEOPLE IN A SETTING

Nothing is more basic to art and literature than recording our own lives. Putting people in a setting means painting people in the context of their home life, work and surroundings. Artists differ in their approach. Some focus on relationships using the setting as 'background music', while others record the activity and work that people are engaged in, using the setting as an important part of the message.

The camera has made the task of taking the visual notes easier. Many artists use both candid snaps and sketches done on the spot for reference. The photographs record the actual shapes and detail while the drawings fix, both in a tangible form and in the artist's memory, the impressions of the scene.

PHOTOGRAPHING PEOPLE
The manner of photographing the subjects differs according to the type of painting the artist intends doing. The basic photographs must suit the needs of the composition. 'People in a setting' are usually taken unaware, so that their natural movements and activity are not disturbed by the intrusion of the photographer.

The methods are the same as those used by photo-journalists operating at speed as an event unfolds. The first thing to remember is to use a fast film, depending on the lighting conditions: 400 ASA is a good choice. A camera with an automatic exposure meter is a help, but not absolutely necessary. With a manual camera the shutter speed should be set at about 250th of a second. The exposure can be adjusted before you turn to focus directly on the subject, so as not to alert them.

USING THE IMAGE
Snatched photographs will probably need quite a bit of alteration in the composition.

Pictures of people need a certain relatedness, an interaction or common focus of attention. You can enlarge or diminish the figures, turn them around or move them closer together. You can add in part or all of a different background.

Along with the activity of the people, the setting that they are in tells us a great deal and can be used to create a mood. A bright sunny day gives the painting a positive feeling; change the colours to slightly cooler hues and deepen the tone, and you will give the painting quite a different impression. The same photographs can be used for several paintings as you explore some of the potential moods.

OUTDOOR SUBJECTS
Jackie Simmonds travels extensively, like many artists today. She enjoys sketching and painting, but this is frequently very difficult to do on site. The camera is now an

◀ Source photograph for *Market Corner, Ubud, Bali* by Jackie Simmonds.

established part of her painting kit, along with her pastels, watercolours and pads.

For example, Ubud market in Bali was a wonder for the artist, but hardly a practical place to paint, with all the people jostling about. Jackie took a number of photographs of stalls and the people that she would be able to work from later in her studio. Quick outdoor picture-taking needs a lightweight camera and at least a 200 ASA film, or 400 ASA if the light is poor, which should give you enough speed for most situations.

◀ Source photograph including the wicker sunshade added to the painting.

▶ **JACKIE SIMMONDS**
Colour sketch of Bali market
watercolour
205 x 125 mm
(8 x 5 in)
This sketch was done directly from the source photograph to try out the idea for the pastel painting.

▶ **JACKIE SIMMONDS**
Market Corner, Ubud, Bali
pastel
560 x 455 mm
(22 x 18 in)
The key to the pastel is the light falling on the figures and touching the headdress of the seated woman. It unifies the picture and gives it life and a dimension in time. The light was worked creatively with the pastels as the picture progressed, elaborating on the information in the photograph. The cool, dense pastel colours chosen by the artist construct a very different mood from that of the photograph or the watercolour sketch.

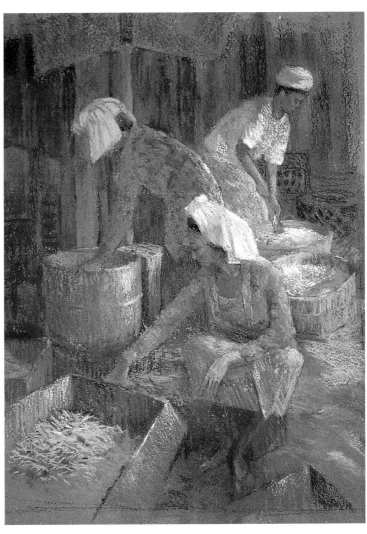

The towpath of a canal back in England posed a different problem – the lack of a vantage point to sketch from. The path was swarming with people and Jackie had to perch somewhat precariously on a low bridge. She made a few quick sketches of the people and took photographs to give her the detail she had no time to paint on the spot.

In London, the constant movement of people and pigeons in Trafalgar Square (see opposite), combined with the freezing temperatures of the winter's day again made any serious attempt at sketching or photography quite difficult. After a few quick notes, the artist decided to take some shots of the people and the background architecture that might serve as the basic elements for a pastel painting. Back in the studio, she used the pictures to put together her composition like a jigsaw puzzle, producing a skilful composite from four of the photos and one drawing.

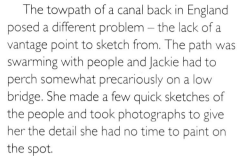

▲ Pencil sketches done on
the spot as reference for
figures on the boat
and towpath.

► JACKIE
SIMMONDS
Canal Boats
pastel
355 x 405 mm
(14 x 16 in)
In the painting the artist
has distanced the people
walking on the towpath,
who are described with no
more than basic pastel
strokes, to clarify our
focus on the boats and
central figures. The
brilliant sunlight on the
towpath and wall was
used to lift the mood
and lead the eye into
the image.

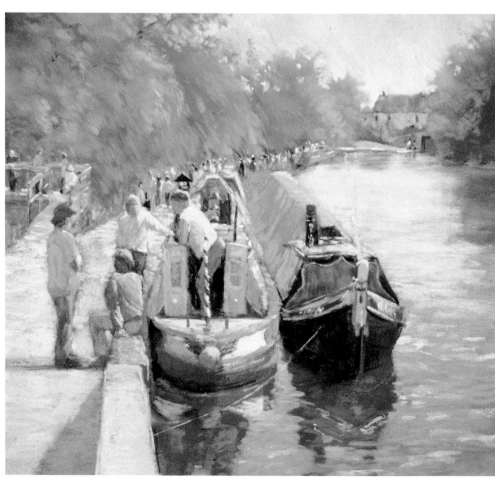

Source photographs
(right and below) for
*Feeding the Pigeons in
Trafalgar Square* by
Jackie Simmonds.

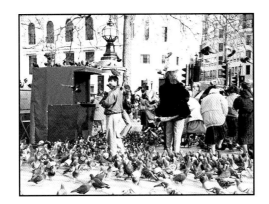

If you are in a similar situation, remember to take pictures specifically of the background setting, which will form the context of the composition later on. Extracting material from those and your figure photographs, you can use tracings and photocopied cutouts to combine the information in one image.

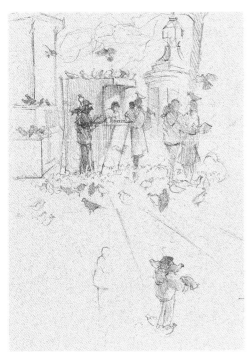

▲ Freehand pencil drawing of the composition. The foreground was extended, moving up the hut and figures, and the birds and diagonal paving lines help to lead the eye towards this centre of interest. Individual figures were taken from each of the two source photographs shown.

▲ JACKIE SIMMONDS

Feeding the Pigeons in Trafalgar Square
pastel
535 x 380 mm
(21 x 15 in)

The well-judged use of blues, mauves and chalky yellows in the pastel composition creates an impression of the cool light of a winter's day. The people clustered in the middle ground naturally draw our attention right into the depth of the composition, while the background and foreground planes give the character of the setting.

FIGURE IN AN INTERIOR

People relax more in their own homes. The furnishings and objects that they have collected over the years reflect their tastes and lifestyles. Domestic detail, above all, puts a person in his or her main context.

New films have made it easier to take decent interior photographs. A very fast film is generally needed: 1000 ASA is a good choice. Flash only illuminates part of the room and distorts the light and shadow. A fast-film picture does not flatten the forms or cast hard shadows.

Sally Strand's camera is as much a part of her sketching equipment as pencil and pad. She uses it to record the throwaway moments, the parts of life so ordinary that they go unnoticed. Sally works quickly, taking the snaps as she can, without intruding, sacrificing any notion of a 'perfect' photo.

Deficiencies in the compositions are dealt with later on when planning the painting. Sally Strand uses slide film and studies the images in a projector that employs available light and a mirror to provide a clear image. She can enlarge, diminish or reverse the slides. Two can be moved about and looked at together to see how the figures might relate. This enables the artist to visualize several possibilities for her composition.

Sally Strand took two reference pictures for this painting. The full view has an interesting contrast of light and shade, but the items on the tabletop are partly obscured by shadow. The second shot was deliberately over-exposed by one stop, so the artist would be able to see the missing detail.

The unusual vibrancy of the lights and colours in Sally Strand's pastel painting comes from her technique of laying in an underpainting on rough watercolour paper, over which the pastel sticks are worked. The heavy grain of the paper picks up glints of colour as the artist builds up the pastel in layers, contrasting warm and cool hues and variable depths of tone.

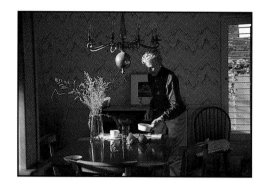

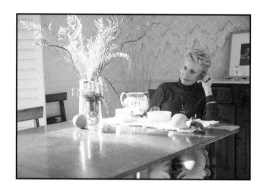

◀ Source photographs for *Laying the Table* by Sally Strand. The top photograph was taken with a normal exposure. The photograph below was over-exposed and shows the details which were lost in the shadows.

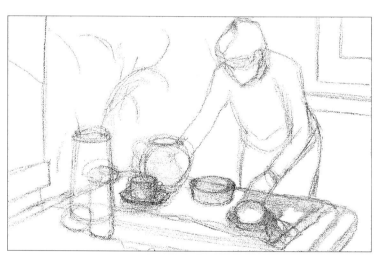

▲ STEP 1
The layout of the composition was sketched in pencil. An interesting element is the way the artist has drawn all the objects on the table in their complete, rounded forms, even where they overlap. This ensured each piece would solidly occupy its own space.

◀ **STEP 2**
The acrylic underpainting was loosely brushed all over the paper, letting the tonal qualities vary and the brush strokes show. This created depth and texture that will give vitality to the subsequent pastel applications.

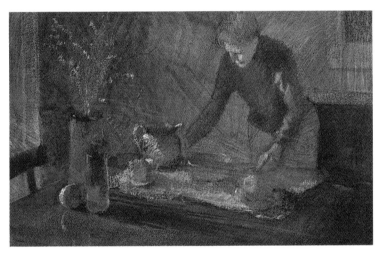

◀ **STEP 3**
When the paint was completely dry the artist began layering the pastel. Working with the broad side of the sticks, she let the colours glide over the surface of the paper, laying in the darkest and lightest tones first. The sharp colours in the highlights appear to shimmer due to the thick pastel being caught by the rough surface of the paper and the acrylic underpainting. The slightest change of pressure on the pastel stick altered the density and brightness of colour.

◀ **SALLY STRAND**
Laying the Table
pastel
405 x 610 mm
(16 x 24 in)
The light has been used to transfer our attention from the woman's face to the objects she is setting out on the table. Highlights of dense pastel throw out the glowing, round forms of the white china, while a lighter pressure 'tripping' over the surface defines the delicate flowers. The finished painting has an edited selection of elements from both photographs.

PERSONAL INTERPRETATIONS

The Impressionists started it all by moving away from strict traditional representation to more liberal and imaginative forms in art. This enabled artists to contribute much greater feeling and mood to their painted images, creating freer personal interpretation of their subjects by means of colour and light. All of Hans Schwarz's paintings could be described as relatively mild in terms of subject matter and design – it is the artist's incredible energy and expression brought to bear on the images that makes them extraordinary.

His desire is to see freshly, with a spontaneous response to his subject. He wants us to follow the activity of his painting, the undisguised brush marks searching for form and creating light. The energy of the activity of painting, and the false starts – all are there to be seen and experienced by the viewer.

His work is based on direct painting from the subject and painting from photographs; he may also use rough sketchbook notes. He takes several photos to build up an assortment of reference material. Schwarz then tries to reduce the subject to its essentials, not only in the details but also in the picture field. The colour is important in determining the 'temperature' of his paintings, which affects the mood and

▲ Source photograph for the main composition of *Village Band* by Hans Schwarz.

◀ Detail photographs of the players. The man playing the tuba at the back of the second picture was also put into the painting but the instrument was changed to a trumpet, which would not obscure his face.

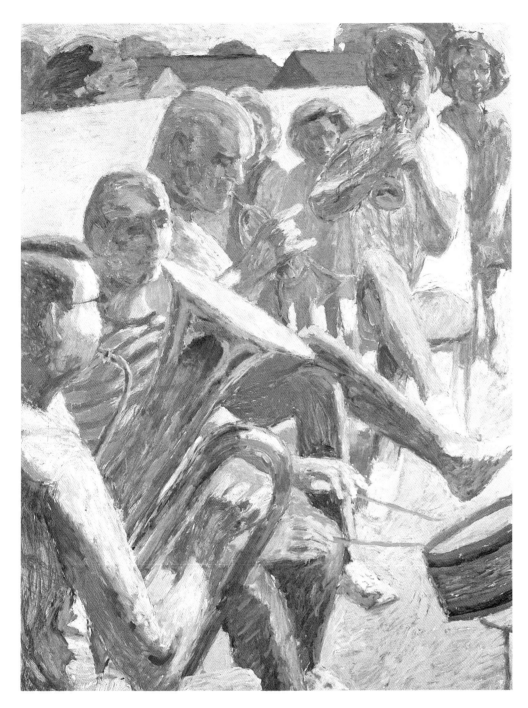

◄ **HANS SCHWARZ**
Village Band
oil
990 x 1220 mm
(39 x 48 in)
The music of the brass band and the heat of summer are both in the colours chosen for the painting. Viridian green and brilliant red are complementary colours at the extremes of the colour scale. Their clashing contrast produces a strong vibration much like the notes of a brass band, and we feel the heat and the white light of the sun in the bleached colours interposed with these powerful hues.

response. His colours and the movement he gives to the figures are chosen to give the expression he believes that individual painting needs.

If you would like to try this free style of interpretation, begin by selecting from your photographs the basic shapes of figures and backgrounds, and abandon interest in the detail. The expressive quality of colour can be used to create a mood or say something about the action in the subject. The sharp,

hot colours of Hans Schwarz's *Village Band* are used to tell us it is a summer's day, and that the musicians are playing jazz.

The manipulation of colour and light to express feelings about a subject is one of the most exciting experiences in art. Several different versions can be made by reinterpreting your photographs in different ways, with a different palette or tonal balance. The more chances you take, the more you will learn about expression.

PORTRAITURE

The art of portraiture has survived the development of photography, and today's artists are using their traditional adversary for their own benefit, rather well. Some artists find the confrontation with a sitter stimulating and absolutely necessary for a portrait, while others prefer a few brief sittings, at which times they will also take photographs that can be used to complete the work. The latter technique is used extensively for commissioned portraits when the sitter's time is limited.

There is a third group of artists who work almost exclusively from photographs. These painters sigh with relief when the sitter finally leaves, preferring the less inhibiting atmosphere of working from photographs. It can be daunting to put in the work necessary to get the painting right when your model has constant access to what you are doing, and expectations of the result.

The type of medium that you choose is especially influential to the mood of a portrait. Watercolour is poetic. You enter the translucent veils of a watercolour, while you stand back from the substantiality of a pastel or oil. The character of the medium can be helpful in developing your style and composition in portraiture, and it is always useful to look at the ways other artists have approached this very personalized area of expression.

▶ Source photograph for *Portrait of Cheryl* by Donald Cordery. The photograph's warm colour was the result of using daylight film indoors by lamplight.

▶ **DONALD CORDERY**

Portrait of Cheryl
watercolour
305 x 225 mm
(12 x 9 in)
Watercolour was the perfect choice for this sensitive study. The artist has kept the warm colour, conveyed by a limited palette of burnt sienna, Indian yellow and crimson alizarin used as the palest of washes in several thin layers. He allowed each wash to dry thoroughly between applications.

PHOTOGRAPHY FOR PORTRAITURE

Whenever possible, natural light should be used in taking the photograph for a portrait. The light from a flash flattens the form, bleaches out the detail and distorts the shadows, which are important to the painter. Portrait photographs made in a professional studio with multiple lights are difficult to work from – the artificial light bathes the figure from too many directions.

This is one situation where the interests of the painter and the photographer diverge. The painter needs the dark tones of shadow for the structure of the face and the general composition. Portrait photographers prefer bright, diffuse light, which fills in shadows and flatters the subject. I try to use existing light, or a highly sensitive film – at least 1000 ASA, which with normal daylight through a window can provide a workable photograph.

If you must use flash take several photographs at different distances to be sure of getting a workable print. Flash is very unpredictable; experience is the only answer. Pose your model in the middle of a room, away from the walls, to avoid a hard cast shadow in the background. Use a normal daylight film – 200 ASA with a flash. An ultra-sensitive film will bleach out prints and add too much contrast.

If you plan to take photographs using normal lamplight, the prints from daylight film will look golden, due to the colour of the bulbs. Tungsten film is colour-corrected to give a natural look. The alternative is using a blue filter, which gives virtually the same effect as using tungsten film. A tripod is usually essential for the long exposures needed to take photographs by lamplight.

▼ **SHEILA JOHNSON**
Portrait of Trevor
pastel
405 x 355 mm
(16 x 14 in)
The informality of the source photograph is reflected by the broad sweep and loose textures of the pastel painting, which contributes to the relaxed mood of the portrait. The directness of pastels enabled the artist to create the striking contrasts of warm flesh tones and cool surrounding colours with immediacy and freshness.

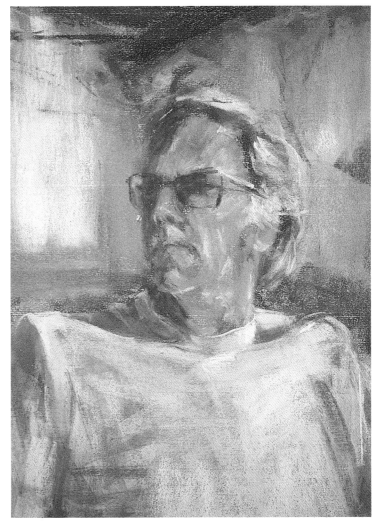

▲ Source photograph for *Portrait of Trevor* by Sheila Johnson.

TRADITIONAL PORTRAIT METHOD

In this oil portrait, Francis Martin used the classic method of scaling up the picture. The finished portrait is a sensitive study that looks as if it took several hours of sittings. In fact, use of photographs meant that the model was required to pose for only a few minutes.

Before he began painting, the artist decided to work out the tonal balance of the composition from a meticulous drawing. The source photograph was overlaid with a numbered grid, from which the pencil drawing was scaled up. The tonal structure was thoroughly evaluated in the drawing and used as a direct guide for the painting. The artist related the tones of the hair, the dress and the background to the fairness of the woman's skin tone.

The grid was used to enlarge the work on to the canvas. The artist used the traditional oil painter's technique of tinting the canvas, applying a thin coat of grey-green. This undercoat was a cool and neutral colour, suitable for depth in the shadows and to contrast with the warm, flesh colours. Both dark and light flesh tones were slowly built up against the grey-green base tone. The method of painting 'fat over

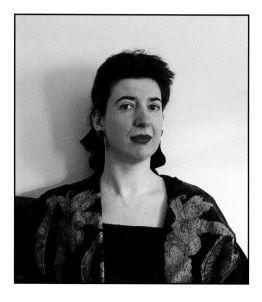

◀ Source photograph for *Woman with a Shawl* by Francis Martin.

lean' was employed, using thinned paint for the underlayers and gradually building up to undiluted paint for the final layers.

Francis Martin works with a simple range of colours: white, black, cobalt blue, light red and yellow ochre. He adds to these basic colours when he needs a special mix; for example, the blue dress in the portrait is based on ultramarine.

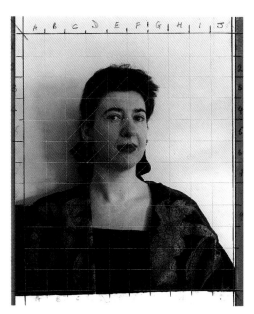

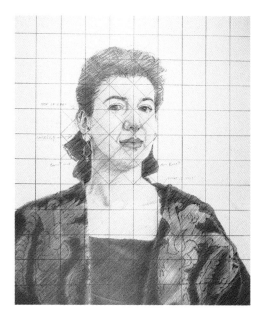

◀ The photograph overlaid with an acetate grid for scaling up. The area over the face has been subdivided with diagonals to make a finer grid for copying details of the features.

▶ The scaled-up pencil drawing showing the tonal structure in detail.

▶ STEP 1

The undercoat was allowed to dry completely and the image was then drawn on to the grid of the canvas in pencil, following the grid of the drawing. The light tones of the face were laid in and modelled with middle and darker tones, establishing details of the features right away.

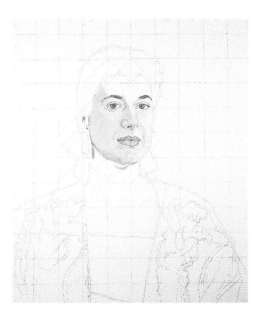

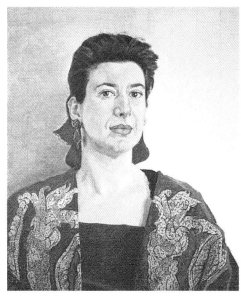

▲ STEP 2

The basic tones and colours of the underpainting were left to dry before the final stage of the painting was begun. The variations in the flesh tints resulted from varying the proportions in mixes of the basic colours and adding white to them. The artist wished to express the sitter's character by means of this harmonious, restrained use of colour.

◀ FRANCIS MARTIN

Woman with a Shawl
oil
305 x 255 mm (12 x 10 in)
A cool grey was added to the background to contrast with the flesh tones. The final layer of flesh tone is thicker. This stands out, giving the flesh depth and bringing out the warmth and form of the face. Facial features and the pattern on the shawl were added last.

TRACING-TRANSFER OIL TECHNIQUE

In contrast to the tradition of building up layers of paint used in the previous example, this painting was done with the direct alla prima method. The term means 'at the first stroke' or 'all in one go'. The portrait took only a day to complete, with the oils remaining wet throughout. This does not allow the painter to work over or on top of the colours without them mixing. A precise plan is necessary if the paint is to be kept clean and fresh.

When Christian Furr takes the photographs for a portrait, he tries to get near to his concept of the finished painting. The lighting is kept as simple as possible, so the form of the face can be looked at almost as an object. He prefers static poses, that imply the portrait has been painted from a photograph. He wanted a soft, natural light for the *Portrait of Emma*, and managed to use daylight by positioning himself outside an open window while the model sat just inside the room.

To transfer the portrait image for the painting, the artist made a simple pencil

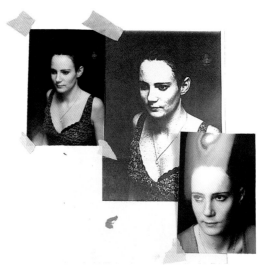

◄ Source photographs pinned to the studio wall for *Portrait of Emma* by Christian Furr, including a photocopy which was used as reference during the painting, to help to clarify the tonal pattern.

sketch by tracing the photograph. He wanted an accurate 'map' of the forms and tones of the face. An enlarged photocopy of the tracing was made and the image was transferred to a piece of hardboard which had been sanded down and covered with two coats of acrylic primer.

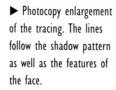

◄ The tracing from the photograph, with tonal detail shaded.

► Photocopy enlargement of the tracing. The lines follow the shadow pattern as well as the features of the face.

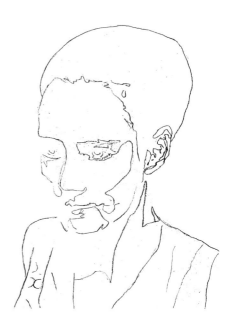

▲ Pencil drawing from life, made as additional portrait reference.

◄ STEP 2
To establish the pale skin tone, he worked back from the light tones to the darker shadows. A dark background began to bring out the form of the face, which was developed with flesh-tone mixes balancing warm and cool colours. The artist worked on all parts of the painting together at this stage.

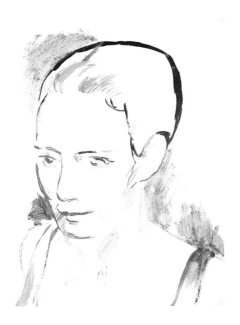

▲ STEP 1
Using a soft, round brush, the artist began to draw the lines of the portrait and indicate the tones, both on the face and in the background.

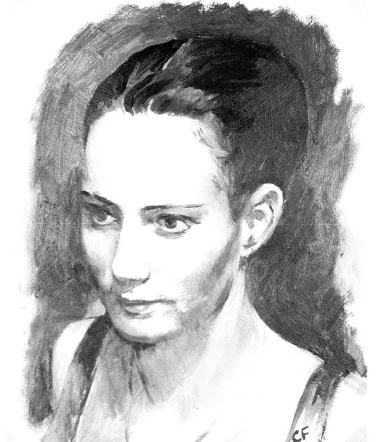

▲ CHRISTIAN FURR
Portrait of Emma
305 x 255 mm
(12 x 10 in)

The tones were slowly reinforced and deepened. The background was sketched in at the left for a looser, more concise statement of a drawing. The highlighting and details of the features were added last. This oil painting took five hours.

PORTRAIT FROM A HOLIDAY SHOT

One of the greatest pleasures of working from photographs is the ability it gives you to recall happy memories and paint people as they were in a special place at a special time. The painting is moved out of the confines of the here and now. Painting this holiday portrait, I could sit in a London studio with rainy weather outside, and remember a bright day in Sardinia.

My original source for the painting was a transparency. I had a colour laser copy made to work from. The face was too abruptly cut off at the bottom of the frame, so I drew in the chin and neck, extending the drawing on the laser print. I made a simple cross on the print with pencil and ruler to divide the image into quarters and used that as my

◀ Source photograph for *John in Sardinia, 1982* by Diana Constance.

guideline for transferring the image freehand on to pastel paper.

I placed the large shapes into the composition first, then gradually added the details. The features had to fit into the curved form of the face to be convincing.

◀ The colour laser print extended by pencil drawing and marked with the crossed lines that gave me a guide to enlarging the portrait.

◀ **STEP 1**
I used a neutral grey pastel to sketch in the basic shapes and then started blocking them in with the broad sides of the pastels. The basic flesh tones were pale cadmium orange and light crimson alizarin.

▲ STEP 2
The forms were developed using light ivory for the highlights and a pale viridian in the shadows. I wanted contrasts between these and the basic flesh tints. Viridian is the coolest colour, and its pale tone introduced a tension of warm and cool against the orange that created a sharp 'edge' to the pastel painting.

▲ STEP 3
The first layers of pastel were thinnish, as I always allow the opportunity to make changes in the drawing. With the format settled, I added heavier colour layers and started to blend. Blending in the background made it recede. The sunglasses enabled me to contrast the smooth texture of the glass against unblended textures in the skin, hair and hat.

◄ DIANA CONSTANCE
John in Sardinia, 1982
pastel
355 x 380 mm
(14 x 15 in)
In the final stage, to make the point emphatically that this portrait was painted from a photograph, I added the black strip with sprocket holes at top and bottom that you see when a transparency is viewed simply as a piece of film.

PORTRAITS IN CONTEXT

Putting a person into a clearly defined setting in a portrait can say something about the person or create an unexpected or witty context for the portrait image. In these two examples, one has a straightforward but descriptive background of the sitter's own environment. In the other, the background setting is 'borrowed' from art history, which causes us to think twice about the context and what we assume about this person.

For his portrait of *Mr Maneck Dalal*, Christian Furr positioned the sitter in the conservatory of his own home. This was not a casual choice, but deliberately intended to be an expression of the person.

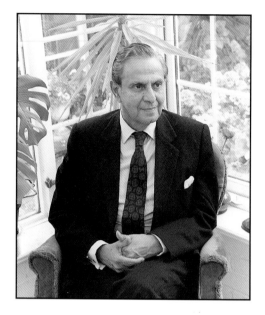

◄ Source photograph for *Mr Maneck Dalal* by Christian Furr.

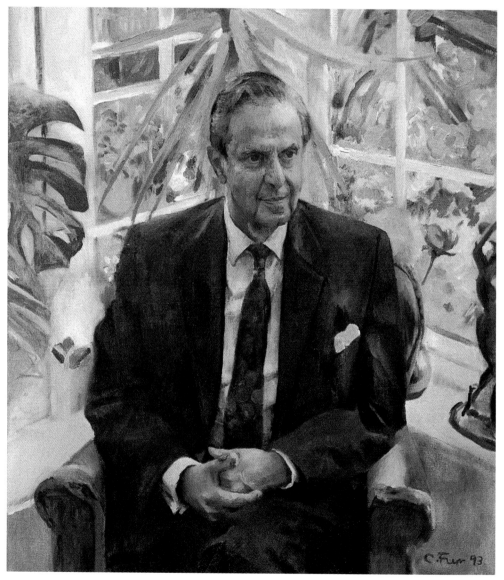

◄ **CHRISTIAN FURR**
Mr Maneck Dalal
oil
875 x 710 mm
(34½ x 28 in)
The solid, dark tones of the sitter's clothing focus attention on the figure, as does his central position within the format of the canvas. The plants are painted in a lively, colourful style, but with lower-key tone and detail so that they stay in the background and do not compete with the portrait.

The plants were painted with great care, to reinforce the sensitive, introspective mood of the portrait.

Forty-eight exposures were taken for the portrait, to find the right pose and accumulate enough information for the artist to work with in his studio. He traced the photograph he had chosen and enlarged it to the canvas size in a photocopier.

In the second portrait shown here, Christian Furr has placed a contemporary young man in a landscape background taken from a painting by eighteenth-century British painter Thomas Gainsborough, who is known for his portraits in outdoor settings. There is a long tradition of artists copying or adapting styles of the past, which may be sometimes intended as homage to a particular person, period or style, or may be a way of challenging their own techniques and compositional skills.

The young man who posed for the portrait was seated in a small room. It was impossible to get back far enough to take a complete photograph, so the artist took three overlapping shots that could be joined into one larger image, which would also enable him to see the detail more clearly. Working from a reproduction of the Gainsborough painting, he drew the landscape background and the dog on to the canvas, then made a tracing of the figure which he enlarged on a photocopier and transferred to the canvas.

▶ Source photographs for *Young Man Seated in a Gainsborough Landscape* by Christian Furr. The artist has managed a corresponding perspective and scale in each exposure to join the three pictures into a single cohesive image. He lacked a wide-angle lens which would have enabled him to take one photo in the small room.

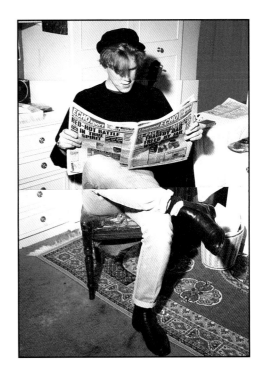

▶ **CHRISTIAN FURR**
Young Man Seated in a Gainsborough Landscape
oil
305 x 225 mm
(12 x 9 in)
Broad brushwork against the eighteenth-century background gives vitality and contrast. The painting is witty and humorous, projecting a student reading a newspaper into a Gainsborough setting.

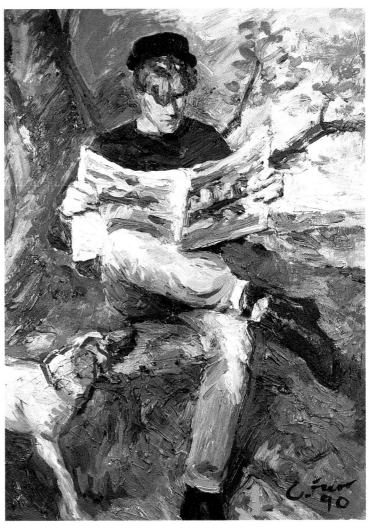

SPECIAL PASTEL TECHNIQUE

This unusual technique produced a pastel painting that looks in itself like a photographic image. It is fascinating because of the ambiguous nature of the work. The open weave of hessian was used as a coarse screen through which the pastel colour was pressed down on to paper. The layer of pastel dust left on the watercolour paper resembles the soft effect of a printed colour reproduction that has been greatly magnified.

The paper was tacked to a board and the hessian stretched over it: it was important to keep the proper alignment, and the artist held the fabric in place with his hand as he worked. First gently, and then more vigorously, an old, hard bristle brush was used to force the pastel through the hessian weave. The pastel lay only loosely on the paper surface, so the artist at various stages checked the progress of the drawing and applied fixative to make sure that the layers of colour could not be smudged.

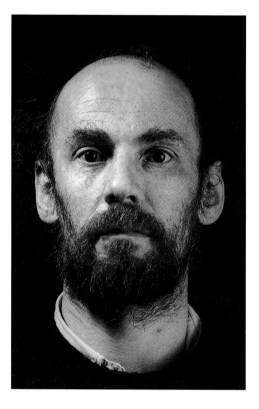

◀ Source photograph for *Portrait of Chris Leinhard* by Justin Jones. The strong black-and-white tonal pattern left the artist free to invent and manipulate the colours of the painting.

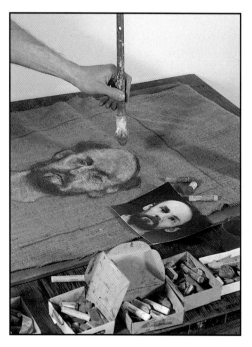

◀ **STEP 1**
The artist first drew the pastel portrait in some detail on the hessian using the tips and edges of the pastel sticks. He then used a hard brush to push the pastel colour through the hessian on to the paper.

▶ **STEP 2**
The image was initially quite faint. After fixing the hessian was realigned on the drawing and the processes repeated to build up the strength of colour and tone.

◄ STEP 3

As the painting progressed, the artist continually lifted the hessian to check the quality of colour and tone, and applied a generous spray of fixative when it was necessary.

▲ STEP 4

Because the hessian held back and absorbed much of the pastel, the colours were used more intensely to enhance the modelling of the face. At this stage, the artist had built up the warm colours more strongly, and strengthened the white highlights.

◄ JUSTIN JONES

Portrait of Chris Leinhard
pastel
635 x 510 mm
(25 x 20 in)
In the final stage, the blue background was added to throw the portrait into relief. The blue pastel was applied directly to the paper and blended for a flat, strong effect. The difference in texture between that and the portrait detail created a sensation of depth and shimmering colour much like a slightly out-of-focus colour print.

ANIMALS

This is one subject area in which photography is an essential rather than an aid or inspiration.

PHOTOGRAPHING ANIMALS

Animals are notoriously difficult to photograph. A great deal of time and film is needed to catch just the right moment. You must use a fast film – 400 ASA in normal daylight and 1000 ASA for poor light or indoors. These highly sensitive films will give your camera the extra speed needed to catch the animal in motion without blurring. To photograph a bird in flight, you will need to set the shutter speed to 1000th of a second; a dog or cat can usually be photographed at 1/250th.

Cameras with zoom or telephoto lenses allow you to photograph the animal from a distance without disturbance. However, this type of lens needs accurate focusing, and with a moving animal this may not be easy. A camera with automatic focusing will lock in

◀ Source photograph for *Weimaraner Dozing* by Gillian Carolan. The photograph was taken by lying on the floor, with the camera lens matching the dog's eye level.

on the subject for you. The important point with animal photography is to have the exposure time and shutter speed pre-set, so that you can push the button the instant your 'right moment' occurs.

The colour or tone of fur and feathers may present special problems. The details that you need for painting may be bleached out if the animal colour is too light, while a dark coat or plumage may obscure the forms and details in shadow. The answer is bracketing the photographs.

▶ **GILLIAN CAROLAN**
Weimaraner Dozing
watercolour
280 x 430 mm
(11 x 17 in)
The subtle contrast of tone caused by the sunlight has been used very tellingly to describe the form. The light on the dog and the carpet is the white of the watercolour paper, which was reserved as the colour washes were built up.

▶ Source photograph for *Cat Licking Her Paw* by Gillian Carolan. This shows good use of a zoom lens for an intimate portrait of the cat. Because of the short depth of field, the background is muted and out-of-focus.

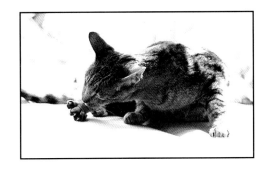

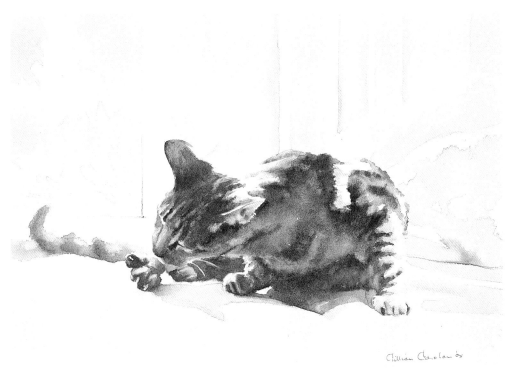

◀ **GILLIAN CAROLAN** *Cat Licking Her Paw* watercolour 305 x 455 mm (12 x 18 in) The artist has captured the stretching movement of the cat, and the curious triangular shape often made by an animal washing itself. The underlying bone structure is clearly visible in this pose. A quick pencil sketch of the twist of the body and alignment of the limbs is often a useful preliminary step before starting a painting.

Doing a painting from just one photograph may not work well unless you have made a study of the animal beforehand. This can be done by sketching directly from life, or by taking a series of photographic studies which you can work with at your leisure. I would suggest shooting a complete roll of film of the animal you intend painting. Try photographing it from several directions; a side view, a front view, from above and the details – paws, tail and, of course, a close-up of the head from different angles. From these photographs you can measure the proportions and study the anatomy.

INDIVIDUAL AND GROUP STUDIES

The work of Gillian Carolan shows a great familiarity with her subjects. In the examples shown on these pages, she has used photographs to isolate a telling pose – the images of the sleeping Weimaraner and the cat washing itself show characteristic elements of each animal's form and behaviour. The paintings interpret the individual photographs quite closely, but their delicacy and accuracy in both cases indicate a thorough background knowledge of the kind of animal this is.

The artist made certain changes that help to focus the subject. In the Weimaraner watercolour painting she simplified the background to concentrate on the animal. The radiator was eliminated and the straight line of the window moved closer to emphasize the relaxed curve of the dog's shoulder and hip. The chair was lightened to push it back visually.

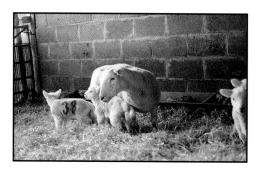
► Source photograph for *Ewe and Her Lambs* by Gillian Carolan.

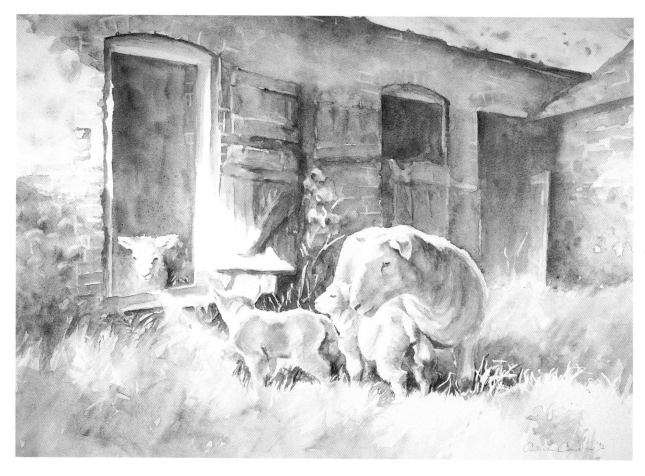

Frequently, the most appealing snaps of animals are set against rather unsympathetic backgrounds. In her painting of a *Ewe and Her Lambs*, the artist has substituted a different background drawn from her own visual memory. The subject could also have been set against a background taken from another source photograph, for example, an open field.

INCORPORATING MOVEMENT
Trying to pose a group of lively animals together is almost impossible. Another delightful watercolour by Gillian Carolan shows how it can be done. A whole roll of film, 36 exposures, was taken of the English setters and out of these she chose three pictures to work from. The dogs from the different photographs were sketched freehand to establish the proper scale and see how the group should be formed. Several drawings were made to decide on the overall shape of the composition. A watercolour study was also made to re-create a colour balance; this is a good idea when you are working from several prints, where a very slight change in the light can cause subtle colour variations.

▲ **GILLIAN CAROLAN**
Ewe and Her Lambs
watercolour
355 x 510 mm
(14 x 20 in)
The subtle coloration of the painting is used to light up and focus the sheep while integrating them beautifully with their new setting. The watercolour gives soft emphasis to the forms.

Source photographs for *English Setters* by Gillian Carolan.

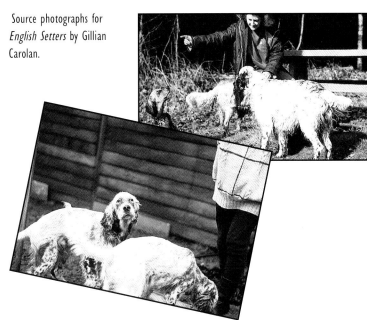

In addition to composing the animals together, a good background had to be found. For this, the artist used the detail of the grasses behind the seated puppy in the second photograph, which was sympathetic to the liveliness of the dogs. The texture and linear pattern of the grass contrasts with the smooth coats of the puppies.

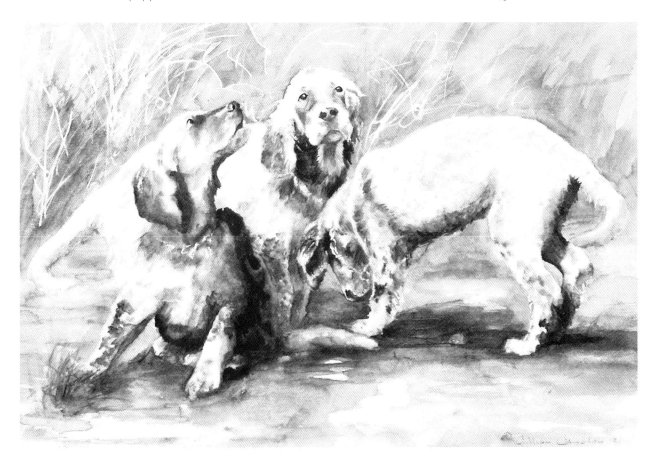

▲ **GILLIAN CAROLAN**

English Setters
watercolour
280 x 380 mm
(11 x 15 in)

The individual poses of the dogs relate well to one another, and create an internal rhythm to the painting. The composition forms a cohesive static image, but the movement of the animals is also freely described by the artist's drawing skill and fresh watercolour technique. The natural and spontaneous look of the painting is a tribute to her careful planning.

PAINTING WILDLIFE FROM PHOTOGRAPHS

Many artists are deeply committed to environmental issues, particularly the preservation of wildlife. Their unique contribution comes in the careful recording of what may become passing scenes in the animal world.

For Bryan Hanlon, there is no substitute for working from life and gaining knowledge at first hand. He works in the field with a sketchbook for immediate impressions, and with a camera for the vital reference photographs he will need in the studio. He uses both as visual information for the paintings and they form a valuable co-dependent relationship in his work.

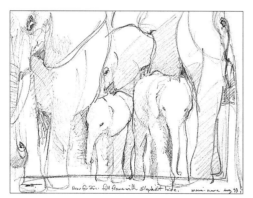

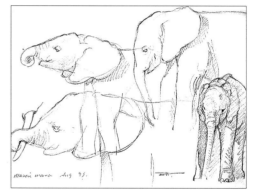

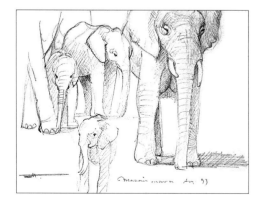

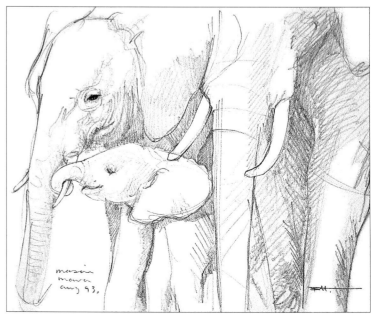

▲ Field sketches of the elephant herd.

▶ Reference photographs for *Elephants and Egrets* by Bryan Hanlon, showing details of body contours, the bulk of the animals, colours and hide textures.

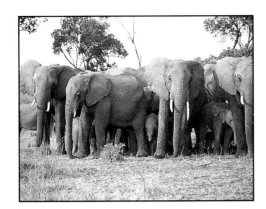

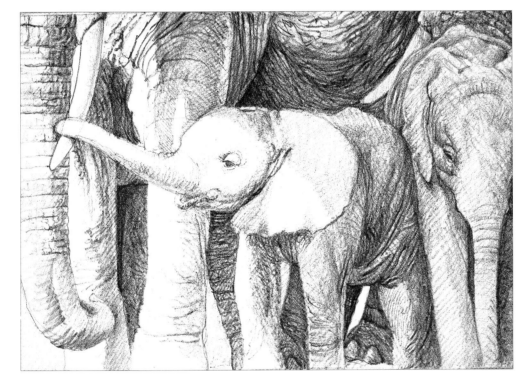

◀ The pencil sketch done in the studio, establishing the form of the composition centring on the movement of the young elephant.

A similar approach can be taken by the less well-travelled artist using found photographs from wildlife magazines, gathering as many pictures as possible to give different views and impressions of the subject. If possible, sketching at a zoo or wildlife park can provide the first-hand observation that will make the paintings more convincing.

While on a field trip in the Masai Mara, Kenya, Bryan Hanlon came across a family group of elephants. They adopted the usual protective, outer-facing circle, with the juveniles finding sanctuary between the legs and trunks of their elders. While observing this mass of blue-grey and beige hides, and the movement of heads, ears, trunks and legs swaying gently and adjusting position, the artist wondered how to depict the scene without repeating the cliches of 'big game art'. He had the idea of filling the whole canvas with 'elephant'. There would have to be a point of interest. The young ones were perfect, being framed themselves by others in the group.

He saw the smallest of the herd gently nuzzle and caress the tusk of another, larger creature. It was over in a blink, but the artist had registered it in his memory and made a quick sketch. He followed up the sketch with several photographs of both the whole herd and details of individuals. It was almost a year later, back in his studio, that he began to work on the composition.

▶ STEP 1

The artist transferred the composition to canvas using the squaring-up method. The surface was primed beforehand with a neutral ground of mauve, grey and beige, which would allow him to begin working the light and dark tones directly.

▼ STEP 3

As the painting progressed, he decided to work around the young elephant and isolate the figure. About the same time, he decided to change the general colour and tone of the picture from a cool grey to a warm brown, using glazes and the loose, semi-opaque painting technique known as scumbling.

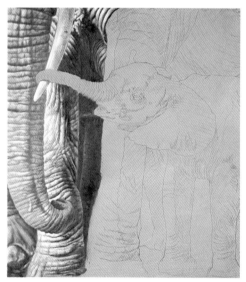

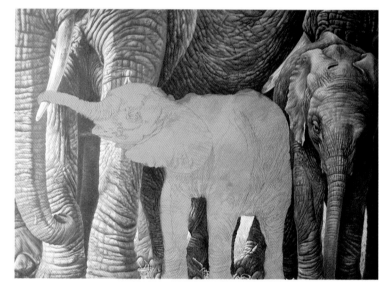

▲ STEP 2

The artist has no set formula for painting, and chose to work on this one by moving across the canvas from the left-hand side. He developed the texture of the hide in considerable detail with its wrinkles, highlights and shadows, dealing with individual shapes that were clearly defined by the drawing.

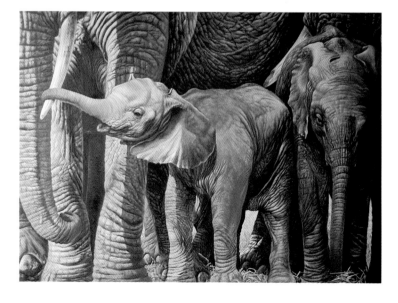

◀ STEP 4

With the young elephant isolated, the task of painting it became very focused. The gradations of colour and light were important, not only to show that the small creature stood in the shadow of its elders, but also linking the subtle colour variations travelling across the painting as a whole.

▶ STEP 5
The artist felt he needed added interest in the composition, so he introduced a couple of cattle egrets, the type of bird that is often an integral part of such scenes. The information was taken from a sketchbook, and the birds were drawn on the canvas using thinned paint and a fine brush.

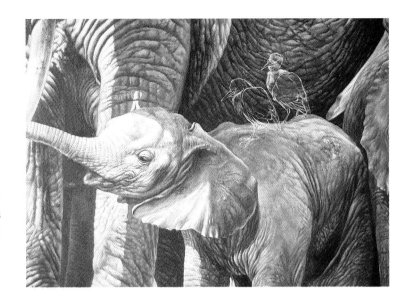

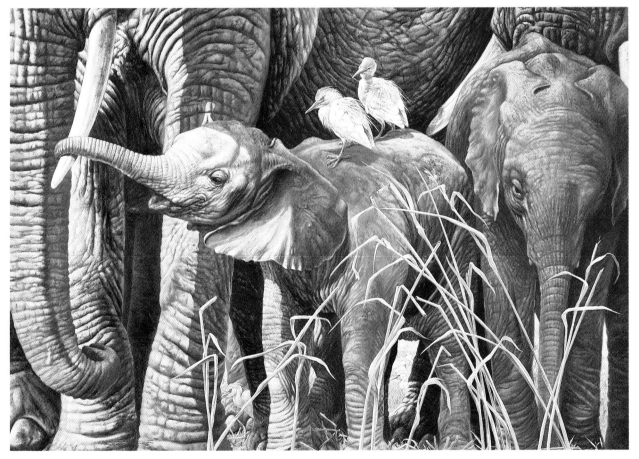

▲ BRYAN HANLON
Elephants and Egrets
oil
455 x 610 mm
(18 x 24 in)
At the final stage, the artist felt that the painting lacked depth, although apparently finished, and that the elephants were too close to the viewer. He added the grasses in the foreground, which gave the painting a contrast of texture and had the effect of pushing the elephants back and creating more space and 'air' in the composition. The warmer tones were achieved by applying translucent oil glazes.

PAINTING BIRDS

In the days before photography, stuffed birds were a common feature of artists' studios, but they no longer have to be drawn from the sad specimens of the taxidermist's art. Photographs taken while bird-watching can provide excellent material for compositions. Ideally, you can use a telephoto lens, and take a simple sketching kit to note down colours, details and the mood of the landscape, whch will complement the photographs and allow you to record ideas for further use.

Since most bird photographs are taken quickly, it is often necessary to change or add to the background of such wildlife pictures. A few general photographs of the landscape, while you are waiting for the birds to make their appearance, can come in handy later on for studio work.

Although pelicans are substantial birds, they can move with astonishing speed. Their flight had to be photographed quickly by

◀ Source photographs for *Pelicans Rising* by Clifford Bayly.

▼ **CLIFFORD BAYLY**
Pelicans Rising
oil
915 x 1220 mm
(36 x 48 in)
The flight pattern of the birds was altered and shapes repeated to make a new grouping. The complicated background was changed into a sky filled with clear light and cool colours, to delineate and frame the elegant birds. As a final touch the light on the birds was expanded by the artist.

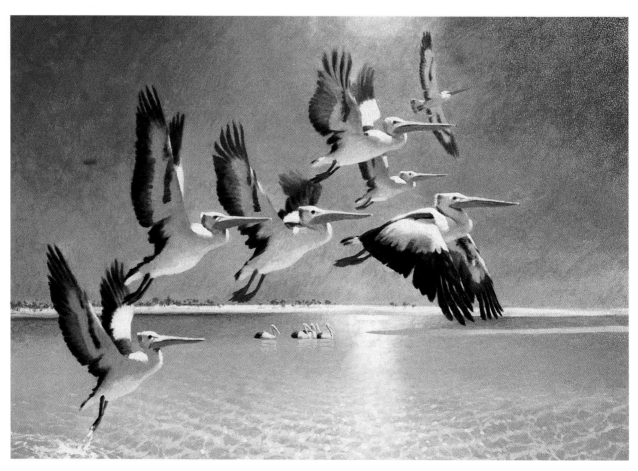

Clifford Bayly, or he would have lost the chance. The background to the pictures was far too distracting, as he knew it would be. Instead of trying to simplify the confusing details, he decided to change the composition completely.

For his study of puffins, Peter Partington took photographs against the warm light of evening, managing to isolate the birds against an unfussy background which showed up their shapes and colours well. Although they are small birds, these photographs tend to make them look large because their surroundings have no detail that gives a clearly comparable scale. The painting retained this ambiguity, while softening the setting and emphasizing the tonal variation of the camphor flowers on the clifftop.

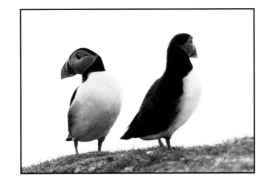

◀ Source photographs for *Puffins on Fair Isle* by Peter Partington.

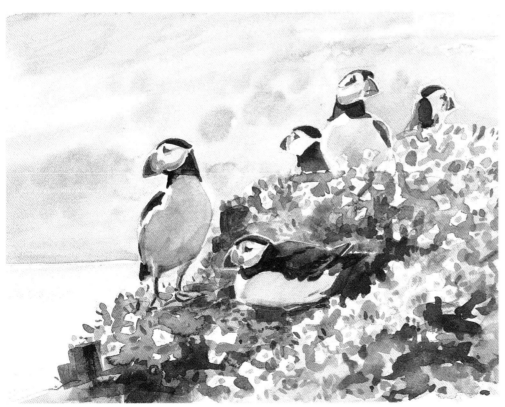

◀ **PETER PARTINGTON**
Puffins on Fair Isle
watercolour
280 x 355 mm
(11 x 14 in)
The initial drawing was intended to capture the constant movement of the birds' heads. The profile views were repeated to expand the group and the seated bird was reversed. The warm evening light was translated with contrasts of warm and cool colour creating light and shade. By tinting the colours of the sky and foliage with alizarin crimson, the sense of warmth was spread throughout the image.

FLOWERS

Although flowers are normally painted directly, there are several good reasons for using photographs. In common with all living things, flowers are passing through their life's cycle. Every day, or hour, brings a certain change. To the casual admirer, this may not be too apparent. However, it is very obvious if you are making careful observations for a painting. After working on a pastel drawing of a bearded iris in the morning I found, on resuming work after a break, that none of the colours I had been using earlier still matched the flower's deepening tones. By the evening the flower had become quite a different bloom.

◀ Source photograph for *A Bowl of Anemones* by Donald Cordery. The real subject is not the flowers themselves but the effect of sunlight filtering through the petals and glass.

▶ **DONALD CORDERY**

A Bowl of Anemones
watercolour
205 x 280 mm
(8 x 11 in)
The artist used thin washes of colour to block in the basic shapes of the flowers, and the shadow areas were gradually built up on top. Several layers were needed to achieve the intensity of the darks, and each had to dry thoroughly before the next one was added. This 'dry wash' technique was specially suited to preserving the crisp edges of the petals. The watercolour retains all the freshness of the flowers, although painted from a photograph.

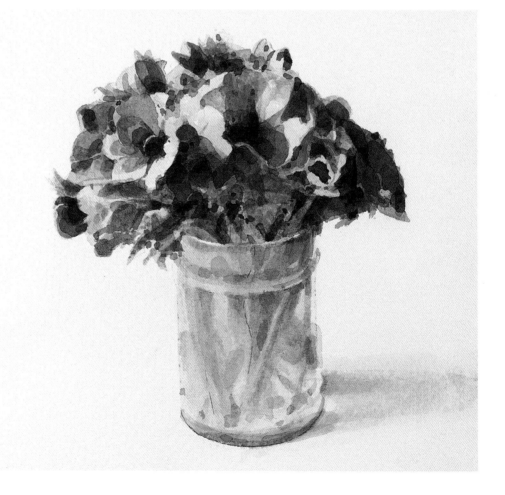

Many subjects, particularly still life, are painted with artificial light in the studio. This allows the artist to return to the subject over a period of time. If natural light is desired, the painter must work at the same time each day to capture the correct impression of light on the subject. Cut flowers will not wait for the sun's return. If you want to hold the position of the light and the freshness of the blooms, you must work with a photograph.

FLOWER PHOTOGRAPHY

Photographing flowers raises few problems. When working indoors, or in poor light, the camera can be placed on a tripod for a long exposure. Fast film is not desirable for flower studies because of its coarse grain.

If you are outdoors with bright daylight, use a fine-grained film, 50–64 ASA, for the subtle texture and details. For maximum effect, use a telephoto, or zoom lens with the fine-grained film for close-ups. On dull days you will need to use a faster film, 200 ASA, on a tripod.

Found photographs – from magazines or plant catalogues, for example, or postcards and prints – are a valuable source of material. They can also provide you with information on unusual, exotic blooms that would otherwise be unattainable. Individual pictures can be used for paintings, or you can combine images from more than one source.

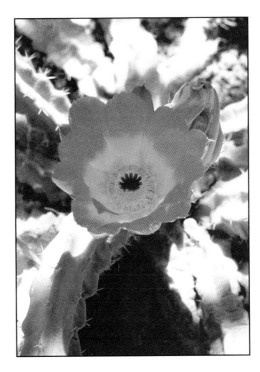

◀ Photographic source, a magazine tear-sheet, for *Cactus Flower* by Estelle Spottiswoode.

▶ **ESTELLE SPOTTISWOODE**
Cactus Flower
pastel
280 x 225 mm
(11 x 9 in)
The artist drew the flower freehand, reducing its size in relation to the page to create space. The contrasts and deeper tones were strengthened to increase the sense of form. The colours and the balance of tones were worked out before details were added.

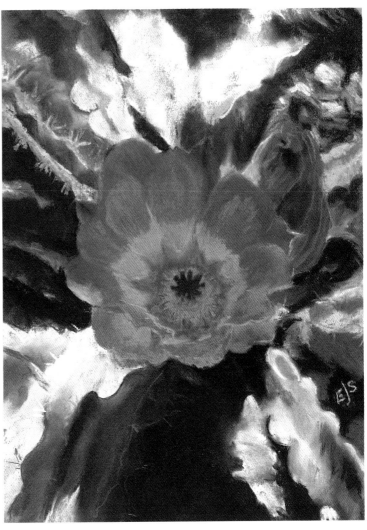

135

BOTANICAL FLOWER STUDY

Botanical artists who frequently have to work on extremely detailed studies over a long period of time use photography as their source of back-up reference material. The life cycle of one flower can be recorded by a method similar to stop-action photography, when a camera is set to take an exposure every few minutes or hours. In this work by botanical artist Coral Guest, the short life span of a single anemone was recorded on consecutive days as the flower slowly opened.

The painting was developed from three photographs taken at different stages of development and drawn into a single composition. Using this technique, there is no reason why a few flowers, photographed over days, cannot grow into a large bouquet filled with buds, half-open flowers and full-blown blooms. This method is useful for recording unusual or exotic blooms.

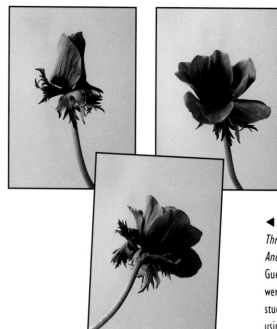

◀ Source photographs for *Three Stages of an Anemone Opening* by Coral Guest. The photographs were taken in the studio over two days, using natural light and 1000 ASA film.

▶ A preliminary study was made to work out the composition, combining the three flowers in a single image. The colours that would be used for the final artwork were also decided upon at this stage, to avoid any need for change or correction in the final detailed watercolour study.

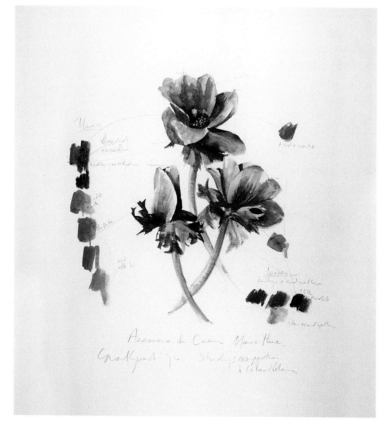

▶ STEP 1

The flowers were drawn
out freehand from the
photographic reference on
640 gsm (300 lb) very
heavy, smooth watercolour
paper. A fine H pencil was
used, and the lines were
slightly lifted with an
eraser, leaving a faint
guide to the layout. The
initial washes were laid in
with a sable brush on a
damp surface, using violet
and a three-colour
combination of
ultramarine, cadmium
yellow and crimson
alizarin for the black.

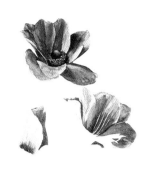

▼ CORAL GUEST

*Three Stages of an
Anemone Opening*
watercolour
405 x 380 mm
(16 x 15 in)
Richer, deeper tones were
added to bring out the
form of the flower heads
and add the detail. The
colours were built up wet
on dry paper and graded
into the lighter areas
with a soft brush and
clean water. The veining
and flower centre details
were defined with a dry-
brush technique. Paler
washes were laid in to
create subtle colour
variations, such as the
pinkish hue (permanent
rose) on the closed
flower bud.

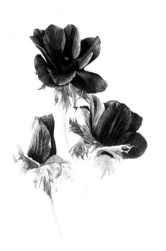

▲ STEP 2

The second stage involved
blocking in the basic
colours and tones of
leaves and stems.
Cadmium yellow and
ultramarine were used to
create a range of greens.
As with the flower heads,
the paint was applied to
damp paper, developing
the overall image to the
point where it could be
reworked to achieve
greater depth of colour.

OUTDOOR SUBJECTS

There are two good reasons for using photographs as reference for outdoor flower subjects. One is the scale and detail of this kind of landscape view; you may not have enough time to do the painting on the spot. Another is the convenience, or lack of it, in working in the open air. Apart from finding a suitable location from which you can settle down to concentrated work, the natural world can cause unexpected problems. This field of wild flowers is an example of the problems you may find.

When Jackie Simmonds sat down to paint these masses of wild flowers in a parched Majorcan field, swarms of insects attracted by the water in her paint turned the prospect of a pleasant afternoon's work into quite an ordeal. Continuing the session on the spot was out of the question; however, the artist was determined to be able to paint the landscape view. She prepared her reference material carefully, including a pencil sketch to show the direction of the light and a quick watercolour note to capture the feeling and impression of the flowers. She also took several photographs from different angles.

Back in the studio, she decided on a vertical format for the composition, with a high horizon to emphasize the depth of the entire field. The watercolour sketch was used to re-create the movement of the flowers, while the photographs provided essential information about the forms and details.

▲ Reference photographs for *Pollença, Wild Flowers* by Jackie Simmonds. The different perspectives enabled the artist to produce a vertical format for her painting by joining views together from different photographs.

▶ Watercolour sketch done by the artist on site as reference for the atmosphere and movement of the flower field.

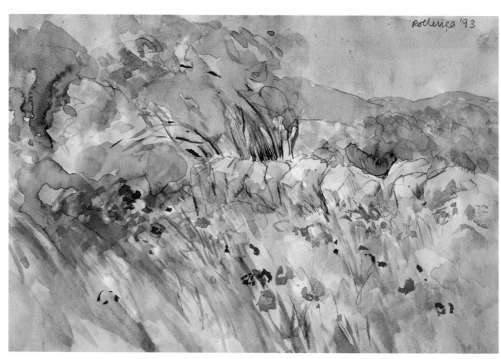

◀ Pencil sketches providing reference and ideas for the format of the painting.

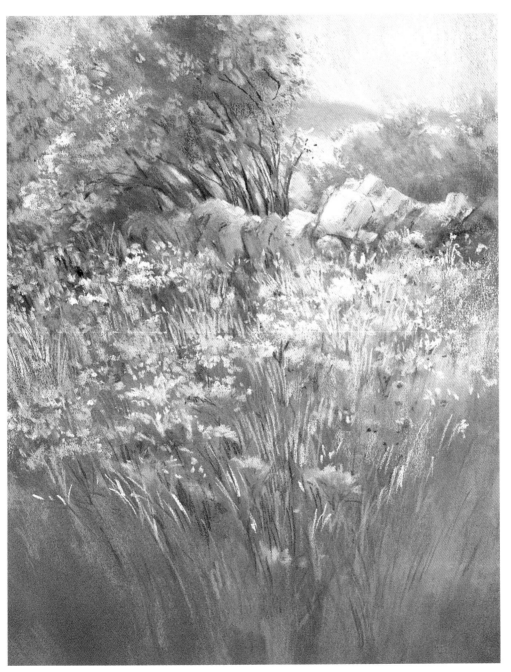

◀ JACKIE SIMMONDS

Pollença, Wild Flowers
pastel
585 x 445 mm
(23 x 17½ in)
The artist has revised the colour scheme within the pastel painting, creating a harmonious palette of blue and mauve tints, with contrasting pale yellows lighting up the flower field and the wall and trees behind. In addition, she has strengthened the accenting of the brighter, tiny yellow and red flowers interspersed with the subtler hues. The directions of the pastel strokes create depth, form and movement.

A GARDEN VIEW

Gathering images of gardens and flowers in their full summer glory can give you something to look forward to in the winter months, when live subjects are few. With a photograph, you can have a whole garden in your studio; its sunlight will not fade, the image waits to be painted.

Luxurious tropical plants, with their clean, simple forms and brilliant colours, are wonderful to paint. I also enjoy the fading, burnt colours of the leaves as they turn and wither. I found this corner of a garden at the Villa San Michele on the island of Capri. What you cannot see in the photograph are the tourists passing through, which would have made working on the spot almost impossible for any artist.

In my photograph taken at normal exposure, some of the flower colour was bleached out by the strong sunlight. This proved to be a problem when I came to start the painting on my return home. I could not find a reference picture in gardening books, but finally my local florist let me sketch the details and colour of the flower from his catalogue.

I used extra-large pastel sticks to work on the bold forms in this painting. The larger the drawing tool or brush, the less likely you are to be mean and fussy with the shapes. This image needed a strong, direct approach; the design and movement of the plants were important and I wanted to capture swiftly the feeling of life and light in the garden.

◀ Source photograph for *Villa San Michele, Capri* by Diana Constance. The original was a transparency, from which I had a colour laser print made.

▶ An enlarged copy of a tracing made from the laser print helped me to sort out some of the confusing shapes that were in the original image.

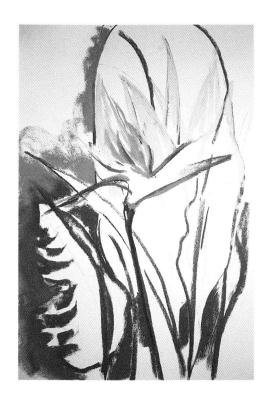

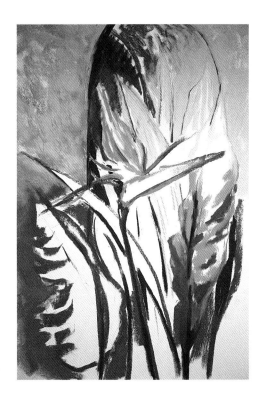

▶ STEP 2

I found the shadow in the photograph too heavy, so I introduced more light by overworking with paler tints. I wanted to oppose the sharp angle of the flower with the sinuous curves of the leaves. To give intensity of contrast to the bright cadmium orange of the flower, I applied cool viridian and French ultramarine.

▲ STEP 1

I drew the composition freehand, simplifying the shapes and putting in basic tones to establish the light in the garden. Using the large pastels, I kept the lines and shapes quite free and bold.

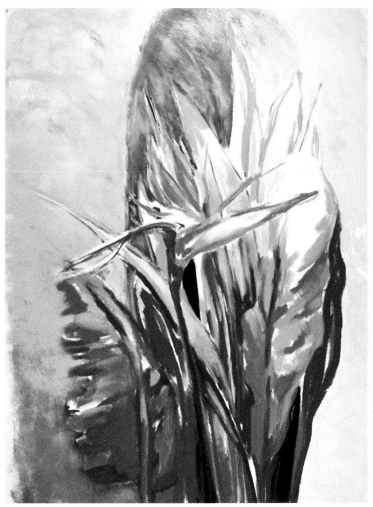

◀ DIANA CONSTANCE

Villa San Michele, Capri
pastel
660 x 510 mm
(26 x 20 in)
A warm glaze of Naples yellow on the wall brought back the sunlight. Yellow was also added to the leaves to increase the warmth and harmonize the shapes. The details of the flower gleaned from the catalogue were put in place, but I used all the photographic reference as a basis for expressing my memory of the brightness and gaiety in the Capri garden.

ABOUT THE ARTISTS

Clifford Bayly studied at St Martin's and Camberwell Schools of Art in London, and taught for many years at the art colleges in Canterbury and Maidstone, Kent. His landscape subjects have embraced Australia, Sumatra and the standing stones at Carnac in Brittany, France. In 1993 he won the Chevron Art in Nature competition and he has regularly exhibited at the Royal Academy Summer Exhibitions. He is a past Vice-President of the Royal Watercolour Society.

Gillian Carolan studied art and design at Kingston upon Thames Polytechnic, Surrey. Her love of animals greatly influences her work in textile painting, appliqué and watercolours. Recently her paintings have been selected for the annual exhibitions of the Royal Watercolour Society and the Royal Institute of Painters in Watercolour.

David Carr studied at the Slade School of Fine Art in London and on scholarship at the British School in Rome. He has exhibited regularly at the Royal Academy Summer Exhibitions and is a member of the London Group. He has been a prizewinner at the Cleveland Drawing Biennale and the South Bank Picture Show. He is the author of two books on painting.

Martin Caulkin studied graphic design and illustration at Birmingham College of Art and Crafts. In the mid-1960s he worked in London as an illustrator and teacher. After publication of his work in print form, he moved to rural Worcestershire. He is a member of the Royal Institute of Painters in Watercolour and the Royal Birmingham Society of Artists, and exhibits regularly at the Royal Academy Summer Exhibitions.

Donald Cordery studied at Winchester College of Art and the Royal Academy Schools in London. He was a prizewinner in the 1964 Young Contemporaries exhibition and in the John Moores exhibition in Liverpool in 1967. He worked with Edward Bawden at Great Bardfield in Essex on a mural for BP-Shell in 1966. In 1989 he designed four postage stamps depicting birds, commissioned by the Royal Mail and the Royal Society for the Protection of Birds.

John Crossland studied at Sheffield College of Art in South Yorkshire, exhibiting with the Northern Young Artists in 1960 at the Huddersfield Civic Art Gallery. He has exhibited in group exhibitions in London and the north of England.

Alison Dunhill trained at Reading University with Terry Frost and Rita Donagh. She has had studios in Florence, Andalucia and Norfolk, and currently paints and teaches in London. She has taken part in numerous group shows and has had several solo exhibitions.

Christian Furr studied at Withen's Lane Art College, Merseyside, and Leicester Polytechnic. He has had several solo exhibitions and was the recipient of the Elizabeth Greenshields Foundation Scholarship for painting in 1991. He has been featured in *The Artist* magazine and the book *Introduction to Oils*, published by Dorling Kindersley. His commissions include a Royal Overseas League portrait commission to paint HM The Queen in 1995.

Coral Guest trained at Chelsea School of Art, London, and on scholarship in Japan studying native flora and calligraphic painting. She has had several solo exhibitions in London and New York. Her work is in private and public collections worldwide and paintings are owned by The Society of Wildlife Art and the Hunt Botanical Institute. Her commissions include commemorative work for the Royal Botanic Gardens at Kew and the Royal Horticultural Society.

Bryan Hanlon is a self-taught painter and sculptor. He works in oil, watercolour, tempera and bronze, and has had numerous commissions. He has a deep commitment to the preservation of wildlife and has recently written a book on African wildlife and conservation.

Justin Jones studied illustration at the Leeds Polytechnical College in West Yorkshire and at the Central School of Art in London. He has travelled widely, teaching and studying in Italy, Spain, Germany and Poland. He now teaches a postgraduate course in painting at the Central School of Speech and Drama in London.

Pat Mallinson studied illustration and painting at Goldsmiths' College and City & Guilds Art School in London. She now works in north London, using etching, paint and pastels. Her work is in collections and galleries in Britain, South-east Asia and the United States.

Francis Martin studied at Chelsea School of Art, London, having begun his career as a picture restorer, which resulted in his special interest and expertise in 18th- and 19th-century painting. He works on portrait commissions and specialist paintings required for film and television.

Peter Partington studied at Bournemouth College of Art and Middlesex Polytechnic. He has had numerous solo exhibitions and his etchings and watercolours of wildlife and landscape are in many private collections. He contributes articles and reviews to *The Artist* magazine. His *Learn to Paint Birds in Watercolour* and *Learn to Draw Wildlife* were published by HarperCollins in 1989 and 1995 respectively.

Hans Schwarz was born in Vienna and came to Britain in 1939. He studied at Birmingham Art School and has written seven books on art. He is a member of the Royal Society of British Artists, the Royal Watercolour Society and the Royal Society of Portrait Painters. His work is held in the collections of HM Queen Elizabeth the Queen Mother, the National Portrait Gallery, and Oxford and Cambridge Universities.

Jackie Simmonds studied at Harrow School of Art. Her work has been shown in numerous exhibitions. Her publications include articles for *The Artist* magazine and her book *Pastels Workshop*, published in 1994 by HarperCollins. She was an award-winner at the Pastel Society exhibition in 1985 and took first prize in the Chevron Art in Nature competition in 1992.

Sally Strand lives and works in California. She has taught at the Colorado Institute of Art and Scottsdale Artists' School in Arizona. Her work has frequently been shown in exhibitions of the Pastels Society of America, and has also been featured on television and in many publications.

Paul Watkins studied at St Martin's School of Art in London. He is a book designer and travel book publisher.

The following leisure painters, studying with Diana Constance at The Hampstead School of Art in London, have also kindly contributed work to this book: **Julia Bastian, Freda Cowell, Sheila Johnson, Barbara Jackson, David Poole, Estelle Spottiswoode, Connie Wang** and **Vanessa Whinney.**

INDEX